IMAGES
of America

ANDERSON
TOWNSHIP

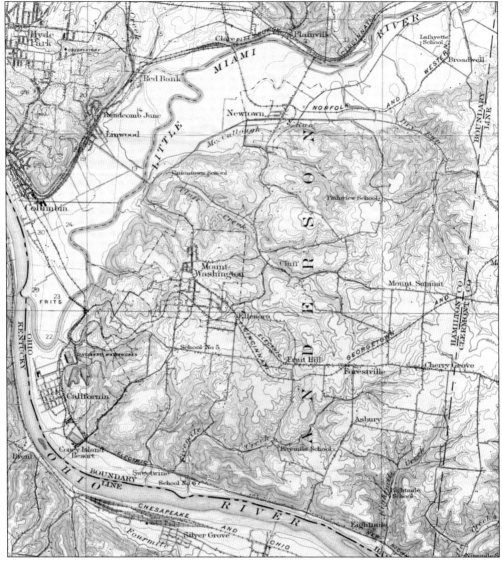

The Anderson area is shown on this East Cincinnati, Ohio–Kentucky topographical map, published by the US Geological Survey in 1914 and reprinted in 1928. The township lies southeast of Cincinnati at the eastern corner of Hamilton County. The Little Miami River and Ohio River border Anderson on the north, west, and south. The map shows the complex landscape of rivers, creeks, lowlands, hillsides, valleys, and plateaus. (From the collections of the Anderson Township Historical Society.)

ON THE COVER: Enjoying summertime in their farming community, the Ebersole family indulge in watermelons on the lawn about 1898. Their ancestor Christian Ebersole was one of the early large landowners in Anderson, purchasing 400 acres along the Ohio River in 1802. Today, part of the former Ebersole property is occupied by the Greater Cincinnati Waterworks. (From the collections of the Anderson Township Historical Society.)

IMAGES
of America

ANDERSON
TOWNSHIP

Anderson Township Historical Society

ARCADIA
PUBLISHING

Published by Arcadia Publishing
Charleston, South Carolina

Printed in the United States of America

Library of Congress Control Number: 2017936106

For all general information, please contact Arcadia Publishing:
Telephone 843-853-2070
Fax 843-853-0044
E-mail sales@arcadiapublishing.com
For customer service and orders:
Toll-Free 1-888-313-2665

Visit us on the Internet at www.arcadiapublishing.com

Dedicated to Anderson Township residents—past, present, and future

CONTENTS

ACKNOWLEDGMENTS

In the spring of 1968, the Anderson Township Historical Society (ATHS) was organized with the declared purpose of creating and building interest in preserving and collecting historical records and artifacts related to Anderson. Members took an active role in collecting such records and items, in particular a remarkable collection of photographs. Over the years, residents of the community shared their family stories and images. Local historians Stephen Smalley (1900–1977) and Roland Lowery (1912–1998) documented the early development of the community, published articles in the local newspapers, and produced illustrated pamphlets on a variety of topics. Publisher and editor Arnold Nichols (1913–1986) wrote articles on the history of the area for the *Mt. Washington Press*. ATHS members with genealogical interests, including Jean Williamson (1905–1987), Betty Wettstein (1916–2007), and others, organized a large collection of family histories. In recent years, accession chair William Dreyer and research chair Nancy McClure (1935–2014) supervised the care and growth of the archival collections. Current research chair Janet Heywood worked on creating digital libraries, starting with the image collections. She has selected a variety of historical images for this book that tell us of the early days of Anderson. We thank Arcadia Publishing and senior title manager Caitrin Cunningham for making possible this volume celebrating the history of the township. As Anderson Township reaches its 225th anniversary in 2018, we hope that current and future generations will enjoy these memories of the past and be inspired by them. All images come from the collections of the Anderson Township Historical Society.

INTRODUCTION

*It is a remarkably well-watered township, pleasingly diversified in its surface,
and valuable in the capabilities of its soil and other products.*

—From *History of Hamilton County Ohio*,
compiled by Henry A. Ford and Kate B. Ford, 1881

Anderson Township was organized as part of Hamilton County in the spring of 1793. Anderson
was the only portion of Hamilton County that was part of the area designated as the "Virginia
Military District," a large tract of land north of the Ohio River between the Little Miami and
Scioto Rivers set aside by the US Congress for Virginia to use as payments to its soldiers. The
township is named for Virginia's surveyor-in-chief Richard Clough Anderson (1750–1826), who
was in charge of the teams of surveyors who worked to divide the large district into parcels. Most
of the Virginia soldiers who received these parcels of land as payment put them up for sale. The
numbers assigned to these military surveys can be found in today's land records.

Pioneers began settling in the area on the east bank of the Little Miami River even before
the land was completely surveyed. Led by John Garard and Joseph Martin, one group came
from Greene County, Pennsylvania. They floated on flatboats down the Ohio River, arriving in
1790. In 1993, an Ohio Historical Marker was placed near the south end of today's Elstun Road
commemorating the settlement they built, Garard/Martin Station, the first fortified settlement
in Anderson. Other families arrived and stayed at the station for protection before building their
own homes. A nearby ford across the Little Miami River, called Flinn's Ford, was used by the
settlers for travel to Columbia, a settlement initiated in 1788 on the west bank of the river, and
farther to the west to the small but growing town of Cincinnati.

Settlers moved up onto the hills and along the creeks of Anderson Township. In 1792, Aaron
Mercer established a settlement in the river lowlands, first called Mercersburgh and later renamed
Newtown. In 1795, Stephen Sutton built a log house on a hill overlooking Garard Station in
what is now Mount Washington. In 1796, surveyor Ichabod Benton Miller purchased 440 acres
of Survey 2276 north of Clough Creek. The wording of his deed suggests he had already built on
the property. His log house is preserved as a historical site by the Anderson Township Historical
Society. The Turpin family of Virginia purchased over 1,000 acres along the Little Miami in 1785;
Philip Turpin established his farm in Anderson in 1797.

After peace was established with local Indians in 1795, settlers arrived in increasing numbers.
The 1850 federal census tallied 3,048 residents in 519 households. Most residents were farmers.
There was a count of 233 farms, ranging in size from 35 to 608 acres. The 1850 agricultural
schedule recorded 624 horses, 37 oxen, 536 milch cows, 241 other cattle, 530 sheep, and 4,287
swine. Yes, in 1850 there were more pigs than people. The 1870 agricultural census counted 336
farms in the township. Corn, wheat, oats, and potatoes were the major crops, with orchard and

market garden produce generating significant revenues of more than $116,000 (more than $2 million in today's currency).

Throughout the 1800s, the major roads in the area were turnpikes, businesses charging tolls. In 1805, settlers along Clough Creek petitioned Hamilton County to survey a road from the headwaters of the creek to the county line. Ichabod Benton Miller was hired to lay out the road; he submitted his completed survey in November 1805, along with his bill for $9.25. Around 1830, the road was established as a privately operated turnpike. Clough Pike remained a toll road until acquired by the county by 1912. Today's Beechmont Avenue was part of the Ohio Turnpike Company until 1905, when Hamilton County purchased it. Other toll roads included the Union Bridge and Batavia Turnpike (State Route 32), Salem Turnpike, and the New Richmond Turnpike (US 52).

Because of the rugged terrain, railroads were not built in the township until the 1870s. Henry Brachmann, a Cincinnati wine merchant who owned a home along Beechmont Avenue, organized a line from Cincinnati's East End through Anderson out to Mount Carmel. The line was eventually extended to Georgetown. The company raised funds for construction costs by selling bonds to area residents. Local farmers signed deeds giving the railroad a 60-foot-wide right-of-way across their lands, without pay, in the anticipation of the benefits of easy travel to Cincinnati and being able to ship fresh produce to market and receive heavy goods. The Cincinnati, Georgetown & Portsmouth Railroad served the residents of Anderson from 1877 to 1935. From 1902 to about 1922, the Interurban Railway & Terminal Company provided service in the township from eastern Cincinnati to Bethel along one branch and to New Richmond on a branch along the Ohio River.

As settlers arrived, they established churches and schools. Early churches included the Clough Baptist Church, built by John Corbly in 1802, and the Salem Methodist Church. The pioneer minister Francis McCormick from Virginia formed the first Methodist class in the Ohio area in 1797 in Milford. He then bought 600 acres in Anderson and built the first Salem Methodist Church building on this land in 1810. The township trustees established public schools in the 1820s. There were 12 school districts organized by 1826.

In the 1910 census for Anderson, 44 percent of employed adults were farmers or farm laborers. At that time, the Anderson census included the villages of Mount Washington and Newtown, where there were local concentrations of shops and industry. The 1910 census tallied some 370 farms, described as truck farms, growing a mix of crops for both local use and sale in Cincinnati markets.

In 1909, the Cincinnati Water Works was completed near the village of California along the Ohio River, and California was annexed to Cincinnati. In 1911, residents in the Mount Washington area chose to be incorporated into the city of Cincinnati.

Anderson remained a farming community well into the 20th century. Population growth was slow. Cincinnati grew and spread in other directions. The Little Miami River was seen as a barrier; floods disrupted bridges and roads.

The completion of the high Beechmont levee and bridge in the 1950s spurred development in the Anderson area. Between 1960 and 1980, the population of the township nearly doubled to over 34,000 residents. Former farm fields provided open areas for new subdivisions. By the 1980s, Beechmont Avenue was lined by commercial development. Public reaction resulted in residents voting in 1987 for local control of zoning. In 1990, residents approved a greenspace levy to purchase and preserve land in perpetuity, making Anderson the first township in the state with its own greenspace program. Since 2000, the population has remained stable at just over 43,500 residents.

Today, Anderson Township is a highly praised community governed by a three-person elected board of trustees, elected fiscal officer, and professional management staff. Anderson is well known for its top-rated schools, thriving churches and businesses, remarkable medical facilities, outstanding parks and recreational areas, and dedicated community involvement in planning for the future.

One

A FINE FARMING COMMUNITY

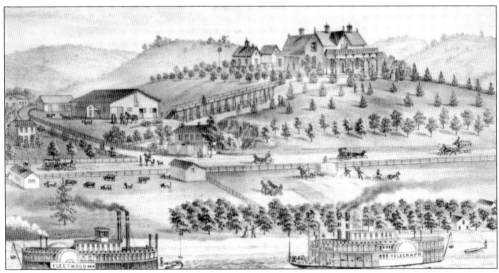

Jacob Markley's prosperous farm in Anderson Township was located along the Ohio River near today's Five Mile Road. It is depicted in the *Illustrated Atlas of the Upper Ohio River and Valley*, published by Titus, Simmons & Titus Company of Philadelphia in 1877. The Markley family arrived in the township in 1814 from Pennsylvania. The family flourished, and Markley children married the children of other early Anderson Township families.

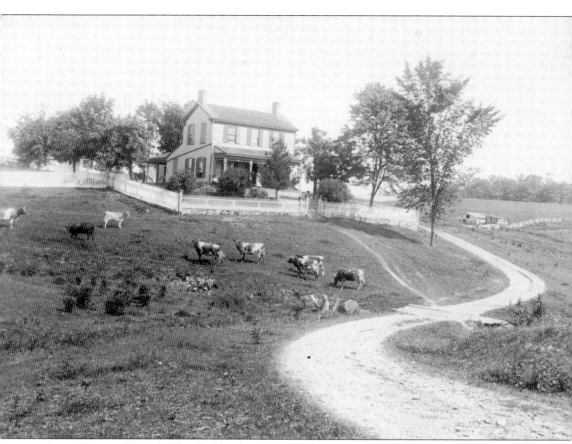

Aaron Hopper (1820–1895) called his farm Fruit Hill. He was the son of Abraham and Elizabeth Hopper from New Jersey, who bought hundreds of acres in Anderson Township around 1814. Aaron started a produce outlet in Cincinnati to sell fruit and products from his farm. He also served as a county commissioner, a township trustee, and a member of the school board. Fruit Hill has become the name used for this area of the township. The photograph was made about 1880 by Andrew Fitch McCall Jr. of Bethel, Ohio. Today, this beautiful home is a private residence on Markley Road.

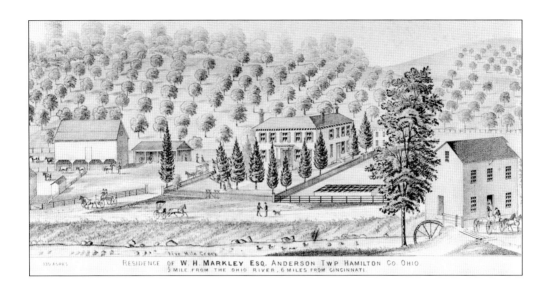

RESIDENCE OF W. H. MARKLEY ESQ. ANDERSON TWP HAMILTON CO. OHIO.
½ MILE FROM THE OHIO RIVER, 6 MILES FROM CINCINNATI

Here are two views of the farm of William H. Markley (1826–1904) on Five Mile Road. Above is an illustration published in the 1877 *Illustrated Atlas of the Upper Ohio River and Valley*. The photograph below was taken about 1916. Studies of the home suggest that the oldest part in the back was built about 1825 and the larger front portion was constructed in 1855. In the 1800s, the Markley family operated a sawmill and gristmill on Five Mile Creek. A mill can be seen depicted in the illustration above; it was probably not located that close to the house.

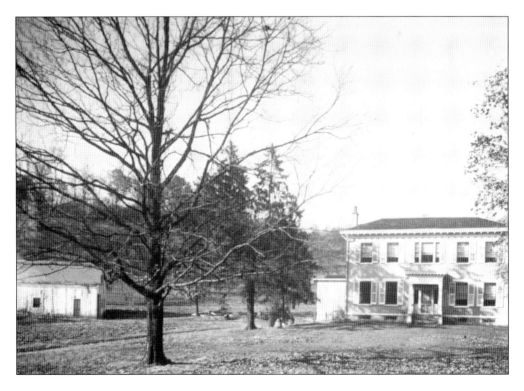

In a 1902 brochure, Anderson Township is praised as a "fine farming community." Clough Valley is mentioned as a particularly fertile area. This 1900 view shows a section of Clough Valley. Rows of corn shocks, as pictured, were once common sights in the fall. Corbly Road runs across the bottom of the image. The building on the left is the Clough District School. Today's Berkshire Road intersects Clough Pike across from the school.

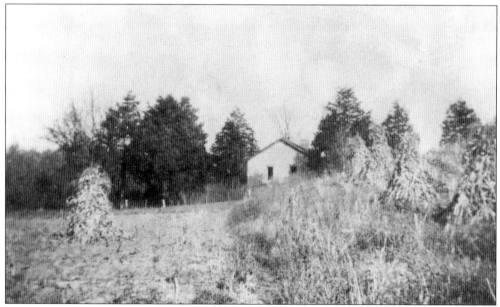

Corn shocks stand in the field near the old Clough Pike Baptist Church building. The practice of bundling and drying out cornstalks in the field was replaced as mechanical harvesters came into widespread use. Today, the corn shocks on display in the fall are likely to be decorations and reminders of the past.

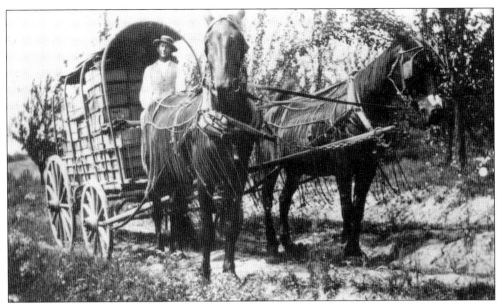

The *Williams Hamilton County Directory* of 1887 describes the very fertile soil of the township and remarks upon the large quantities of fruit, berries, and vegetables produced on local farms that found ready sale in Cincinnati. Edward Keel is seen hauling a full load of vegetables to market from his farm on Eight Mile Road in this c. 1910 image.

Eight Mile Road was lined by farm fields in the 1920s. Farmhouses with barns and other buildings were spread out in the agricultural area. In the distance is the prosperous farm of the John Van Saun family. Today, most of the farm fields have been replaced by residential development. Some early farmhouses remain as private homes; many have modern additions but can still be recognized.

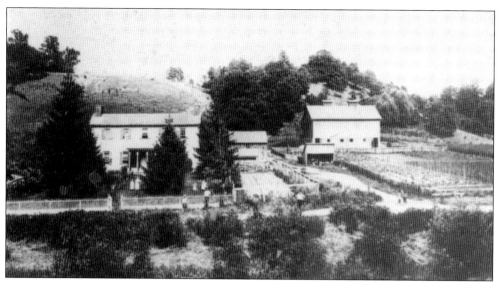

A late-1890s view of the Wolfer family farm includes the large house, barn, other buildings, and 10 family members posed in the yard and along narrow, dusty Clough Pike. The earliest part of the house was built by James Clark Jr. in 1832. Michael Wolfer purchased the house and 63 acres of farmland in 1874. The house was enlarged over time. In 1971, the farmhouse was converted into a modern office building at 6740 Clough Pike.

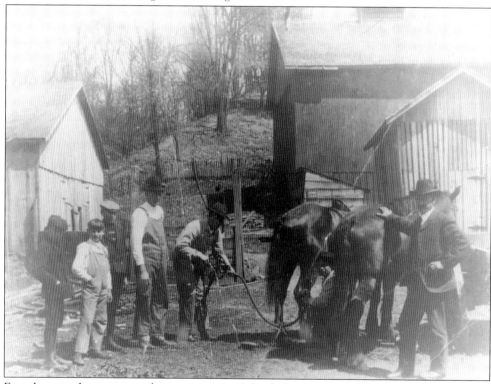

Few photographers were on the scene to record the daily operations of active farms. In this rare photograph taken at the Wolfer farm on Clough Pike about 1900, a blacksmith is seen working on the hoofs of the team of horses.

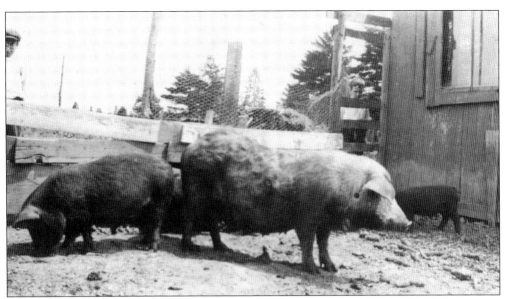

On the agricultural schedule of the 1870 federal census, most of the 336 farms in the township reported keeping one to three milk cows and three to eight swine. This practice of raising a small number of dairy cows and pigs for family use on Anderson farms continued well into the 1900s. On a farm and ranch schedule filed in 1939, William Hornschemeier reported 2 dairy cows, 13 hogs, and 15 chickens on his 100-acre Clough Pike farm. The 1910 photograph above shows two farm boys watching hogs on their farm on Birney Lane. Lawrence Leuser, who lived in the log house on Clough Pike near Bartels Road, also raised a few pigs each year for his family's use. The photograph at right, taken in the fall of 1926, shows him rendering lard in the yard next to his house.

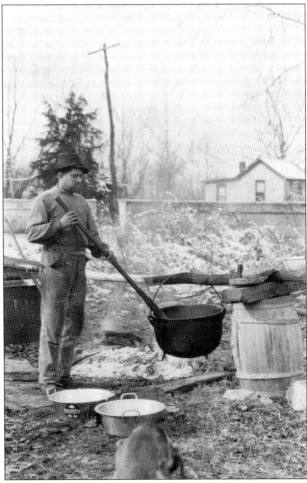

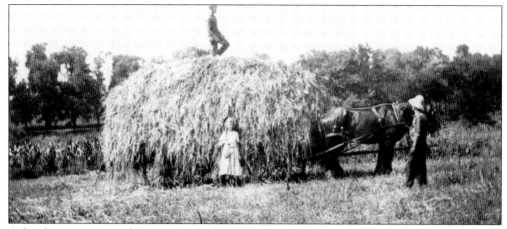

A fine harvest was a welcome event for farming families. This photograph, taken in 1916, shows one full wagon of hay. It was being moved off to storage on the Collord family farm near Barg Avenue. The children seemed happy to pose for the photographer.

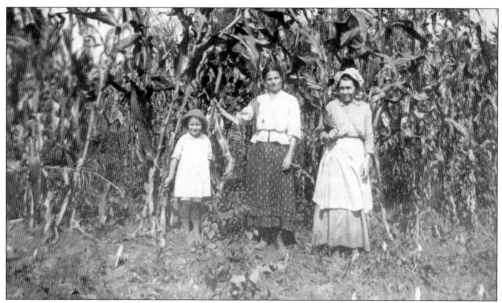

Corn was a major crop for the farms of Anderson Township. From left to right are young Margaret Burnes; her mother, Tillie Burnes; and Margaret's aunt Margaret Katternhorn. They are standing in the family cornfield near Birney Lane around 1920. The corn grew very tall that year.

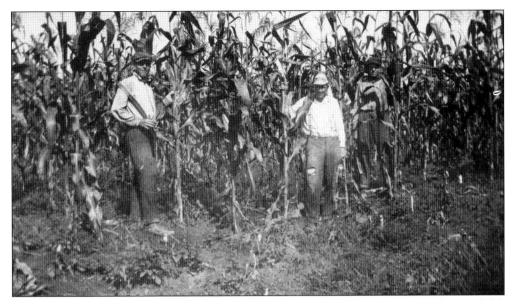

A photographer also captured this image of the men of the Burnes family working in the cornfields of the Burnes farm on Birney Lane around 1920. William Burnes Sr. (center) is seen here with his sons, William Burnes Jr. (left) and Louis Burnes.

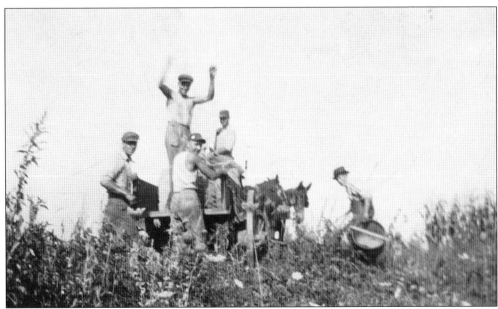

These men greet the photographer as they work in the fields of the Burnes family farm on Birney Lane about 1922. Even one of the mules has turned to the camera. Today, these fields are the Fox Chapel residential area, a development that was started in 1967.

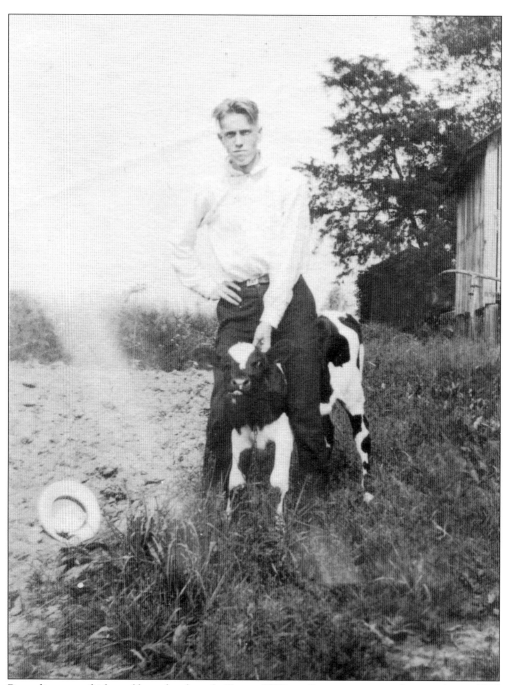

Rounding up a frisky calf was hard work. Young William Burnes is not smiling in this c. 1916 photograph, taken at the family farm on Birney Lane. Most Anderson farm families kept a few dairy cows to produce milk, cream, and butter for the table. Excess products could be sold or traded. Sixty years later, Burnes could remember the favorite dairy cow of the Burnes farm in the early 1900s. The cow produced five gallons of milk a day. There are, of course, developed breeds of dairy cows that are more productive, but the amount was impressive on this Anderson farm at the time.

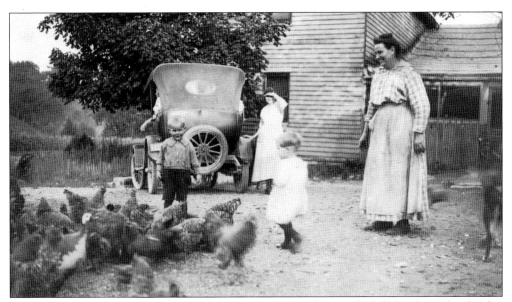

In 1920, Anna Heis Motzer (right) and her young son Louis (boy on the left) lived on Clough Pike, roughly opposite today's Bartels Road. Their flock of chickens filled the farmyard and entertained their visitors as this photograph was taken.

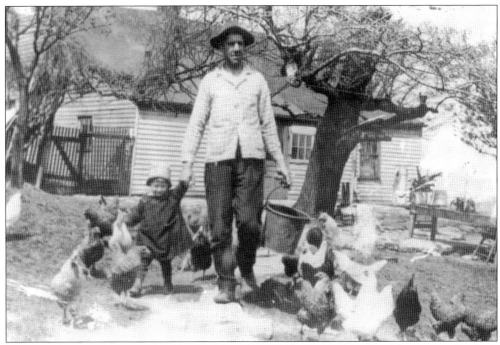

The family of Lee N. Riley lived on a farm above Kellogg Road. He and his young daughter Dorothy were photographed as they fed their chickens about 1923.

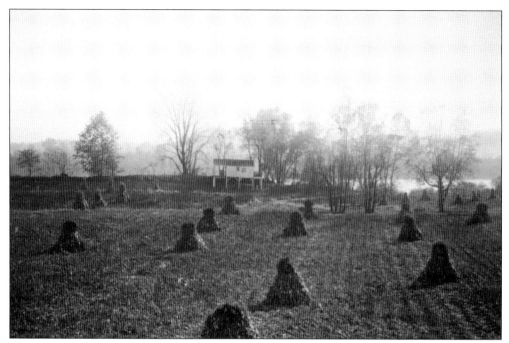

This image, taken in 1916, shows a portion of the Markley family farm along the Ohio River, near the mouth of Five Mile Creek. Corn shocks are drying in the fields.

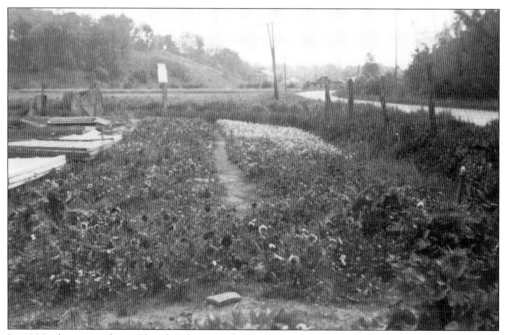

In 1938, this view along Clough Pike includes a portion of the fields of the Leuser family farm filled with flowers and vegetable plants being raised for sale. This is the view to the east of the historic Miller-Leuser Log House, dating to 1796 and now owned by the Anderson Township Historical Society. Today, the section of Clough Pike seen here curving off into the distance is lined by commercial buildings.

Two

HOMES AND FAMILIES

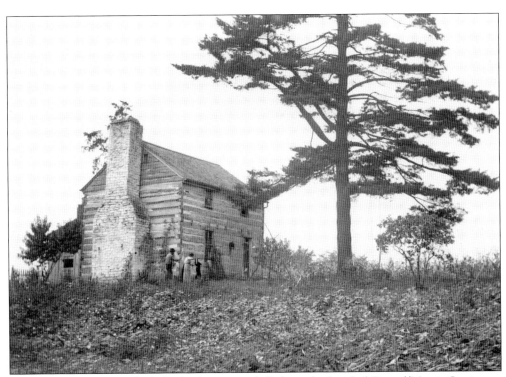

In 1795, Stephen Sutton built this log house on a hill above the fortified Garard/Martin Station on the Little Miami River. Around 1907, Mary Emily Shinn took this photograph of the house. Today, the house, although remodeled, still stands in use as a private residence in Mount Washington on Longbourne Avenue. This is one of the oldest log houses in the state of Ohio that has been continuously inhabited.

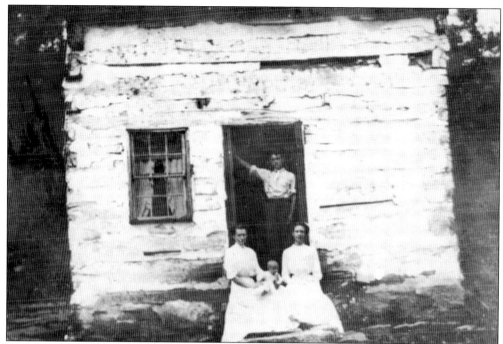

This log house once stood on the land of the Bridges family on Clough Pike near today's Berkshire Road. John Bridges (1745–1823) was one of the earliest settlers in Anderson Township. He was living in a log cabin along the Little Miami River when the Garard and Martin families arrived in 1790. He later bought farmland near Clough Creek.

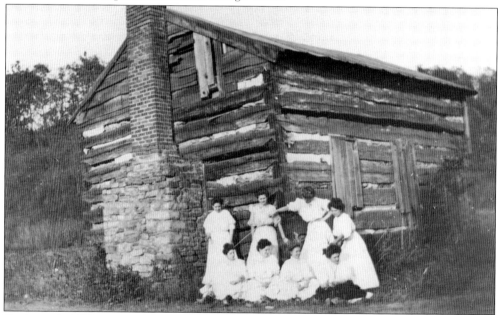

By the early 1900s, most of the small log cabins and larger log houses of the settlers had been abandoned, taken down, or incorporated into larger homes. In the early 1900s, a group of ladies poses in front of this abandoned log house that once stood on Clough Pike, about where Goldengate Road is today. The house had been the early home of Adam Young Sr.

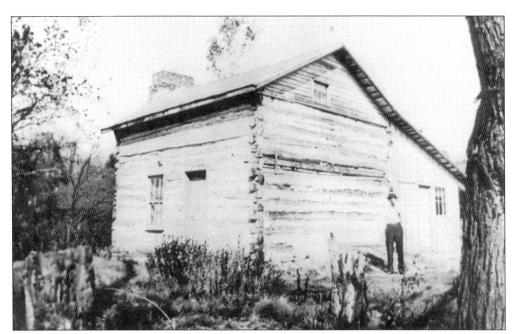

In 1790, surveyor Ichabod Benton Miller arrived at Columbia, Ohio. In 1792, he married Sarah Mercer, a daughter of Capt. Aaron Mercer, developer of the village known as Newtown. In 1795, Miller wrote in his diary that they moved to their own place. This place is known today as the Miller-Leuser Log House. It stands on its original site along Clough Creek. In a 1796 deed, Miller purchased 440 acres on which the log house stood. In 1836, Miller sold the log house with 15 acres of land to Tabitha Noble, who had been renting the house since about 1826. The earliest photograph (above) of the house, from about 1900, shows the original two-story log house with a back room thought to have been added in the 1820s. Noble (right) and her family lived in the house until her death in 1866.

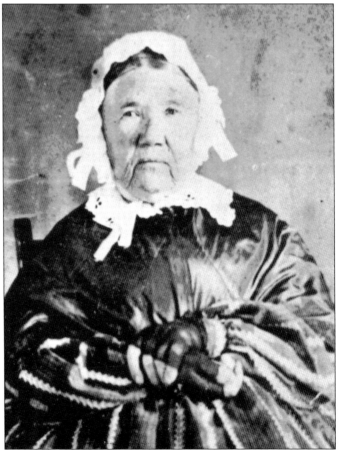

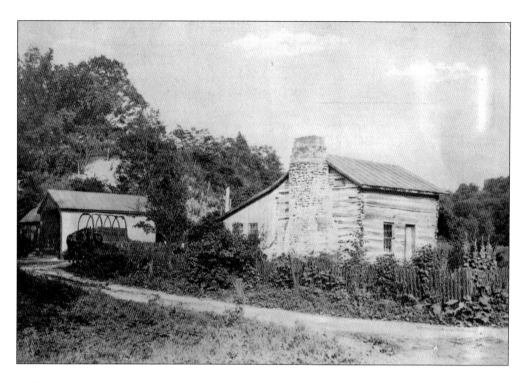

In 1907, Joseph Leuser purchased the log house on Clough Pike originally constructed by Ichabod Miller. Joseph's son Lawrence Leuser and his wife, Emma, came as bride and groom to the log house in 1910 and lived there for over 50 years. One photograph, taken in June 1920 (above), shows the log house and outbuildings. The hollyhocks are in bloom near the picket fence that ran along Clough Pike in front of the house. Another photograph (below) was taken on the occasion of the first communion of daughter Martha Leuser, seated in the center, in 1924. Clara Leuser, Martha's older sister, is the girl on the right in the second row, and the other children are relatives. The building at the right side of the photograph is thought to be a smokehouse.

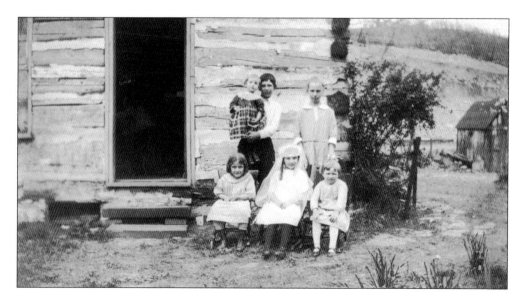

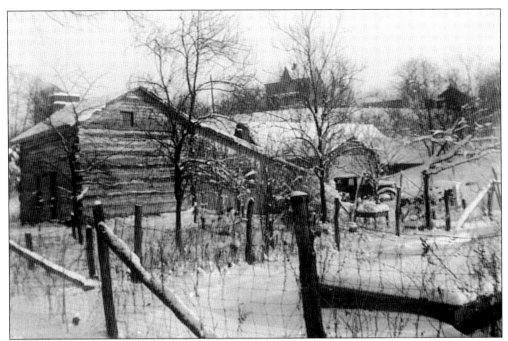

In 1940, the land above the Leuser family log house on Clough Pike was open fields. The farmhouse and barns of the Bartels family farm can be seen on the crest of the hill. Cows grazed on the steep hillside in the summer. Today, this hillside is covered by trees and shrubs.

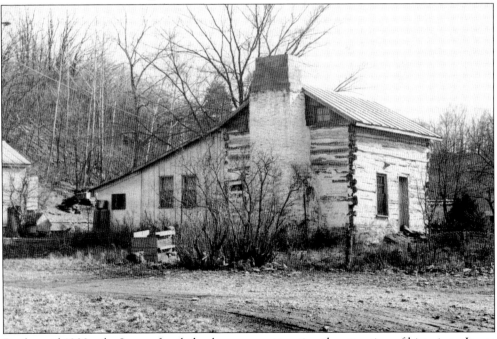

By the mid-1900s, the Leuser family log house was attracting the attention of historians. It was one of the few log houses constructed in the 1790s still standing in Ohio. This photograph was taken in 1955 by local historian Stephen Smalley, who researched the history of older homes in the area.

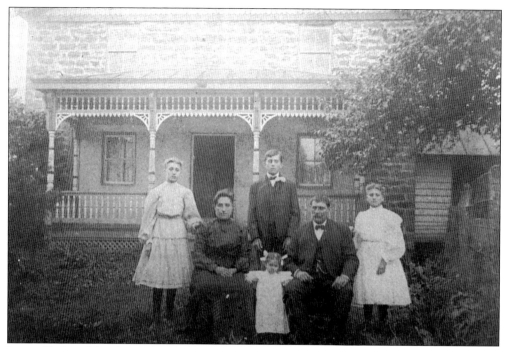

James Clark and family came to Anderson in 1797, bought land along Clough Creek, and built a remarkable large stone house in 1802–1803. It is one of the oldest standing stone houses in Ohio. Adam Leuser bought the house in the mid-1860s. His son Joseph; Joseph's wife, Matilda; and their son and three daughters pose for a family portrait in 1905.

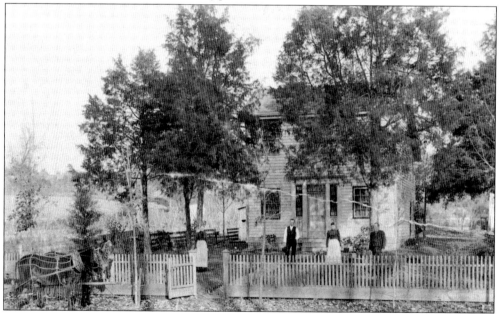

Samuel Woodruff built this house in 1828 on land he inherited from his father. Generation after generation of his family lived in the home. This 1890s photograph shows his daughter Cynthia and her husband, Joseph Mathews (center couple), two of their children, Jane (left) and Joab, and the family mule team. Narrow Wolfangel Road runs in front of the house.

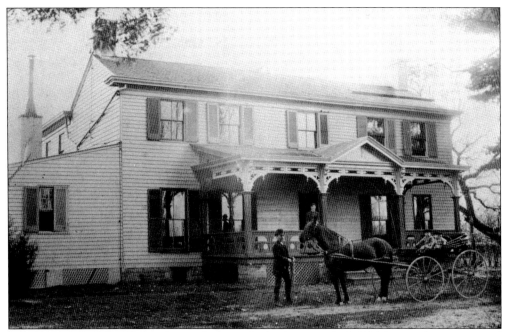

The James Wilson Corbly family was photographed at home, today's 1436 Sutton Avenue, around 1880. James Corbly holds the reins of the horse, his wife is on the porch, and their two young children are in the carriage.

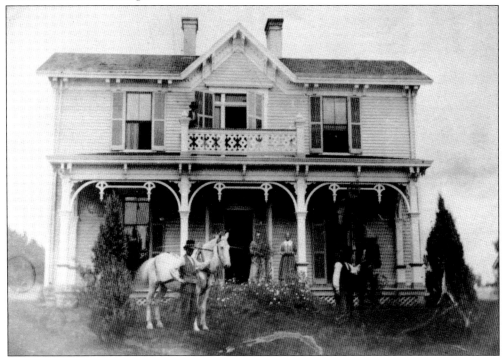

The Carvil Hawkins home, built in the 1860s, once stood at what is now 7820 Beechmont Avenue. The Immaculate Heart of Mary Church used the home starting in 1944 before a new church building was constructed. In 1978, the house was moved to Forest Road.

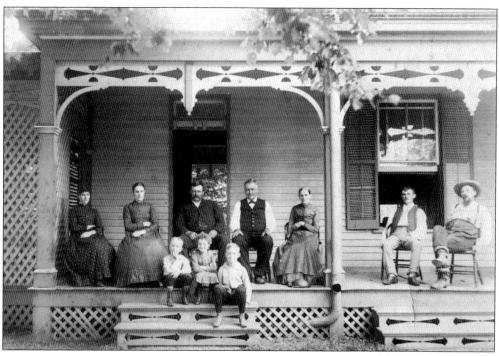

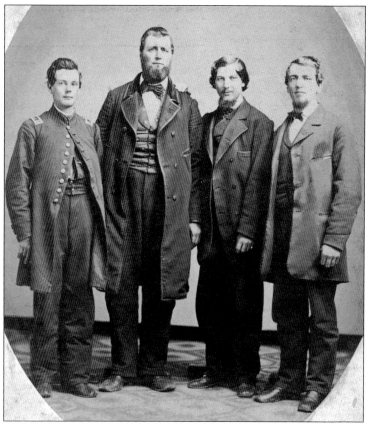

The Aaron Hopper family is pictured above about 1885 relaxing on the porch of their large farm house. Aaron Hopper (center, wearing the bow tie) owned a large farm on today's Markley Road called Fruit Hill. Later, Fruit Hill was the name given to the local post office. Aaron is the tallest man in the group of four men photographed in the 1860s and seen at left. His son Charles M. Hopper (far right above and second from right at left) served during the Civil War in the 10th Ohio Volunteer Infantry; he was a farmer and in his later years was also a real estate agent.

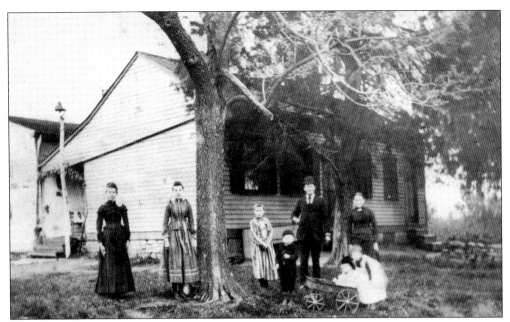

William Godfrey Wolfangel, born in Germany in 1850, came with his parents to the United States in 1852. They were among the many German families who moved to the Cincinnati area in the mid-1800s. He and his wife, Mary, are standing with their children—(left to right) Linda, Carrie, Addie, George, baby Ella, and Emma—in this c. 1891 portrait on the family farm at the corner of Clough Pike and Wolfangel Road.

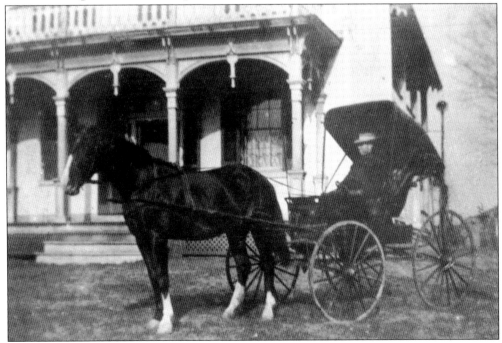

This handsome portrait of a horse and buggy was taken at the John Van Saun home on Eight Mile Road in the 1890s. A bell sits atop the tall pole to the right of the house. Farm bells were essential to communicate with workers on the large farms.

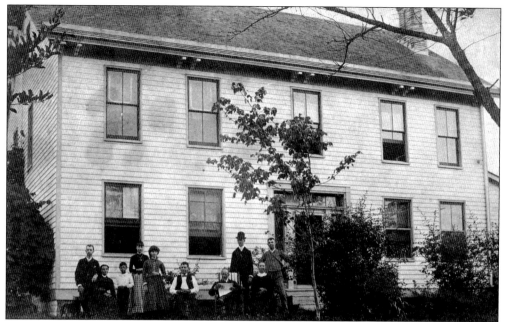

Around 1885, the James O. Johnson family gathered in front of their home south of what is today 8145 Beechmont Avenue. This farmhouse, built before 1870, was the home of several generations of the Johnson and Bennett families. When the New England Club was built in 1985, the house was razed.

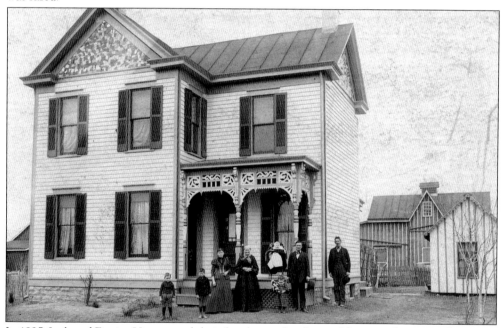

In 1895, Joab and Eunice Hopper and their family stand in front of their new house on the corner of today's Beechmont Avenue and Wolfangel Road. After Eunice died in 1916, Joab remarried. His second wife was not prepared for country life. She sued for divorce on the grounds that she was forced to do common labor from 4:00 a.m. to 11:00 p.m. and her husband would buy her no new clothing.

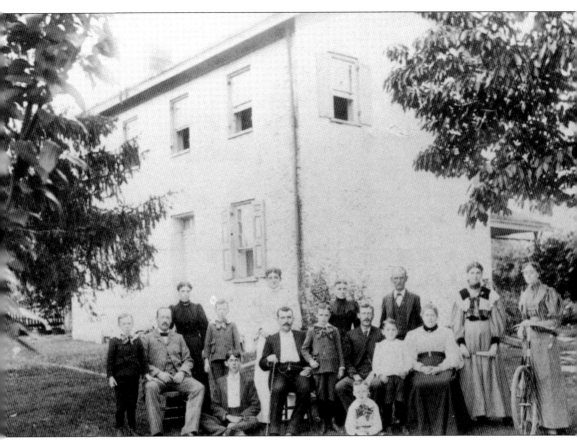

This portrait from 1898 includes two brothers and four sisters of the Silver family. It was preserved with the identification of those present: the adults are, from left to right, (seated) Clement Silver, MD; Herman Holmes (on ground); Louis Higdon; John Silver; and Julia Silver Holmes; (standing) Ella Silver, Emma Silver Higdon, Laura Whitaker Silver, William Holmes, Lillie Silver Holmes, and Cora Silver. The children are, from left to right, J. Perry Silver, Earl Silver, John W. Silver, Clifford Greenwood (young boy seated on the ground), and Samuel Silver. The house and farm were located at the end of present-day Wanninger Lane.

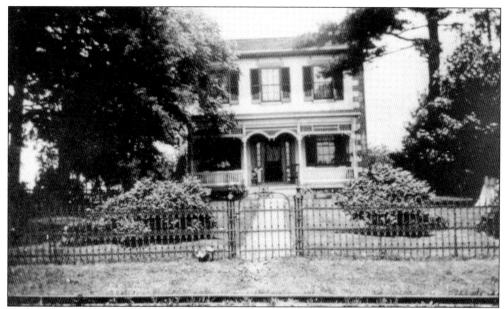

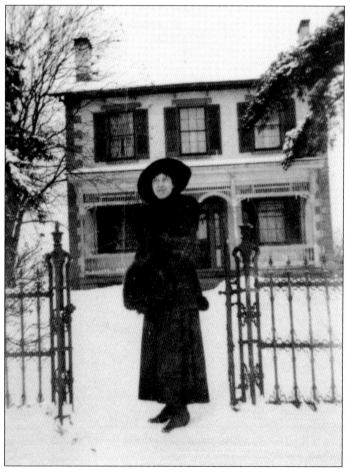

The Johnson family lived in this handsome house that once stood on Beechmont Avenue near the intersection with Collinsdale Road. At the lower edge of the photograph above, the rail line of the Interurban Railway & Terminal Company (IR&T) line can be seen. The IR&T line operated along Beechmont Avenue from 1903 to 1918. Dressed for winter, Bessie Johnson Davis poses, left, at the house on Beechmont Avenue around 1915. A fur muff and wrap were just the thing for a cold, snowy day.

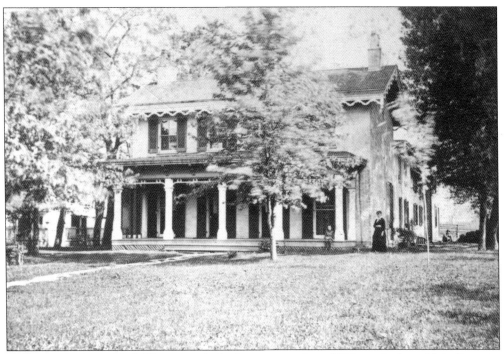

Known as the James McGill homestead, this house, seen about 1900, was built on Main Street in Newtown village around 1830. It remains in excellent condition today and is used commercially.

In 1867, John H. Gerard was elected the first mayor of Mount Washington. He built this home in 1867 at today's 2050 Beechmont Avenue. The house has been expanded and modernized over the years. Since 1933, it has been the location of the T.P. White and Sons Funeral Home.

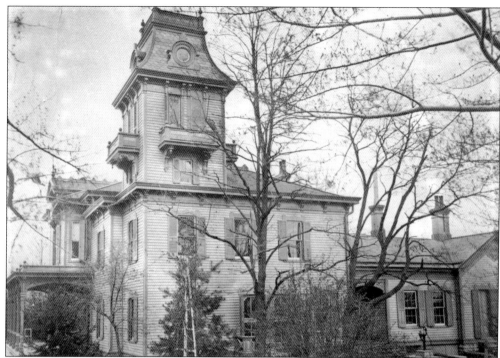

This house was built in 1858 in the village of Mount Washington. It was one of the very few mansions built in Anderson Township in the 1800s. It stood at the northeast corner of what is today the intersection of Beechmont Avenue and Corbly Road. Charles H. Wolff, a wealthy Cincinnati dry goods merchant, chose to build this home in what was considered to be a healthy place distant from the city. He housed his extensive library in a separate two-story building. He purchased the finest bookcases available for his collection of rare books and his extensive collection of Bibles. Wolff also constructed a lake and a bowling alley on his property. In 1888, Albert Andrews, owner of a steel mill in Newport, Kentucky, bought the home; unfortunately, the building burned to the ground in 1897.

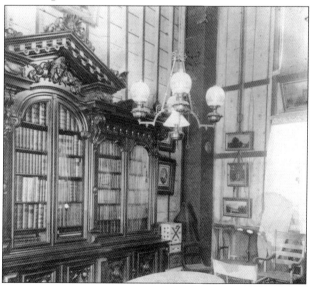

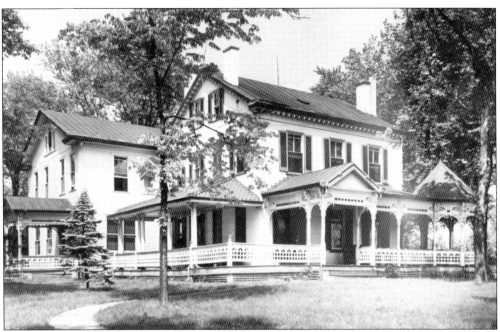

This ornate home on a 56-acre lot at the corner of Beechmont Avenue and Nagel Road was owned by wealthy Cincinnati real estate owner and developer Philip Krug and his family from 1888 to 1947. Krug also served as the president of the Herancourt Brewing Company of Cincinnati from the 1880s to the early 1900s. He was one of the Cincinnati merchants who sought out the health benefits of a home in the clean air of the countryside. The Sons of the Sacred Heart purchased the property in 1947 and used it as a seminary until a modern school was constructed on the grounds. In 1967, the house was razed. Commercial buildings now line Beechmont Avenue, but the many tall evergreen trees around the Comboni Mission buildings at the back of the property recall the early days of the countryside.

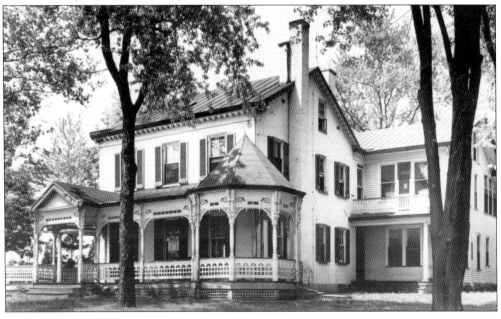

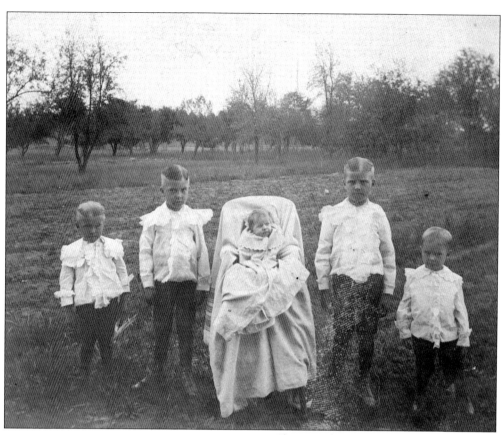

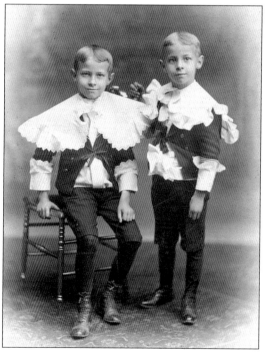

Photographs of children in the late 1890s were not as common as the images and videos that fill family collections today. Those that were taken were precious and generally carefully preserved. The Davis children (above)—from left to right, Andy, Jim, baby Mahala, Hiram, and Mont—are pictured standing in the family fields in Anderson. Brothers Westfield, left, and Justice Widman of Mount Washington pose for a studio portrait (left). They seem proud to be so well dressed for the occasion.

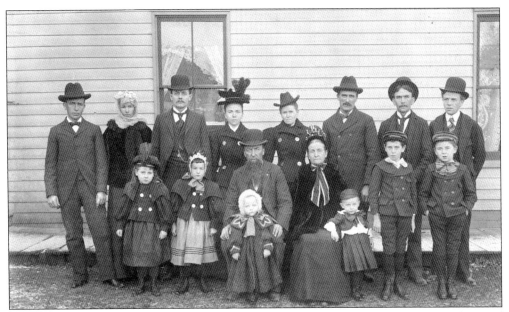

Samuel and Mary Ann Hopper (seated center) are surrounded by their five grown children and their spouses and six young grandchildren in this portrait, taken about 1897. Samuel (1841–1909) was a farmer who later operated a grocery store on Beechmont Avenue and served as postmaster of the Forestville Post Office from 1897 to 1906.

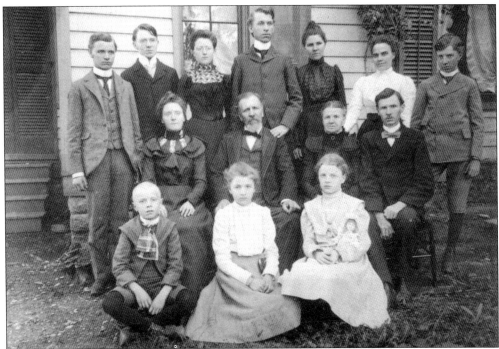

The Mergler family are gathered at their home on Beechmont Avenue, east of the intersection with Mears Avenue, in the fall of 1899. Phillipp Mergler (1846–1919) came to the United States from Germany in 1864. He and his wife, Salomea (1849–1920), raised 12 children. In the early 1900s, he worked as a gilder in an art store.

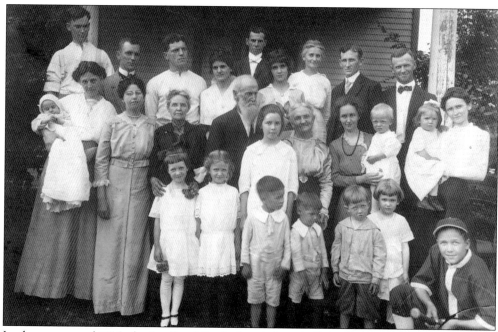

In the summer of 1915, the family of Sanford and Annabelle Nicholson Johnson gathered at their farm on Paddison Road. Sanford (1835–1919) and Annabelle (1850–1933) were married in 1869 and raised four daughters and three sons. Johnson inherited the Paddison Road farm from his parents.

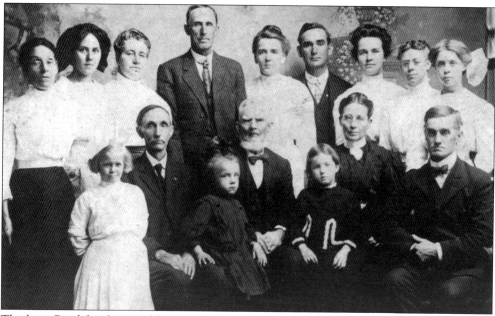

The large Reed family assembles for a studio portrait about 1910. Members of the Reed family owned large farms in the Cherry Grove area for many years. The group includes brothers John (first row, far right) and Clifford Reed (second row, fourth from right) and their sisters Isabel Reed (second row, far left) and Irene Reed Johnson (second row, third from right) as well as their spouses, children, and cousins.

Three

COMMERCE, TRAINS, AND TRAVEL

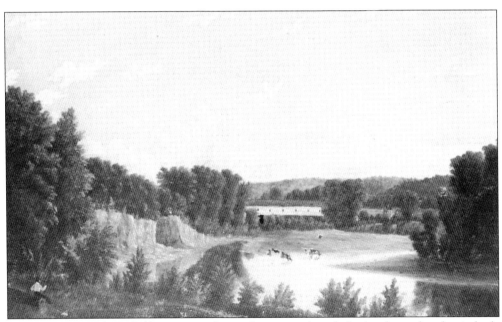

Since Anderson is bounded by rivers on the north, west, and south, bridges have played a vital role in commerce and travel. This mid-1800s painting shows an early bridge over the Little Miami. The covered bridge was at about the same place as today's Kellogg Avenue (US 52) bridge. The sand cliffs in the painting can still be seen and are a reminder of the area's long geological history.

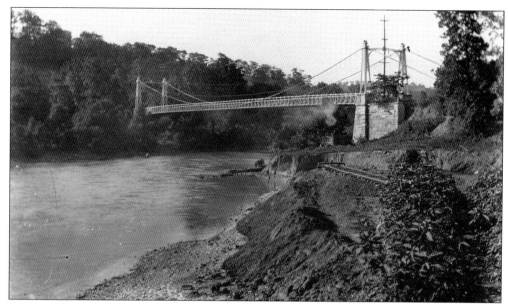

Crossing the Little Miami River to reach Anderson Township from Cincinnati has always been a challenge. In 1876, this 353-foot-long suspension bridge located at the foot of Beechmont Hill was built by Hamilton County at a reported cost of $79,800. The photograph was taken by Mary Shinn around 1908.

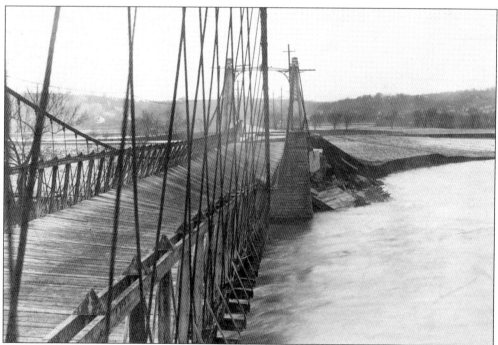

High water during the spring floods of 1913 caused the bridge to collapse. During an inspection tour in Anderson on April 18, 1913, the county commissioners found river currents had washed out great fill areas, torn down retaining walls, destroyed the bridge, and covered roadways with mud. A temporary bridge was constructed while plans were made for a replacement that would be 150 feet longer and eight feet higher.

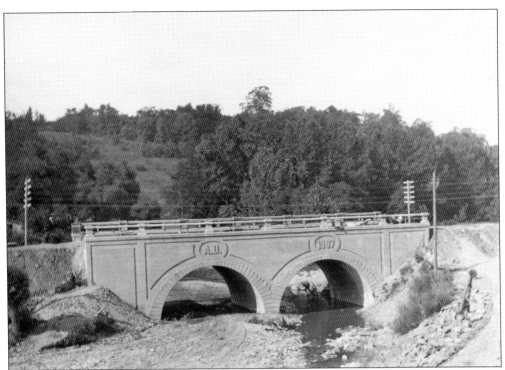

This 1907 bridge was built over Clough Creek near where it enters the Little Miami River. In the 1800s, the road from the Little Miami River up the hill to Mount Washington and then east through Anderson was owned by the Ohio Turnpike Company. In 1905, the Ohio Turnpike from the Little Miami to the Clermont County line was purchased by Hamilton County, and it became today's Beechmont Avenue.

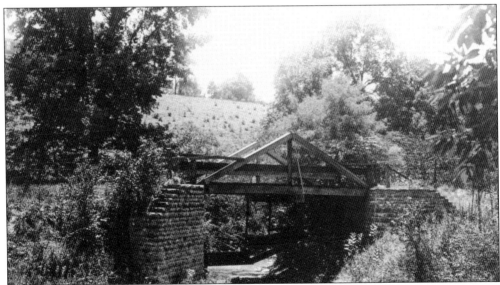

Here is a reminder of the many small bridges constructed throughout the township over the years. Many roads were laid out along the creeks and valleys, and bridges and their maintenance became a necessity. This c. 1900 photograph shows an early bridge on what is today's Berkshire Road.

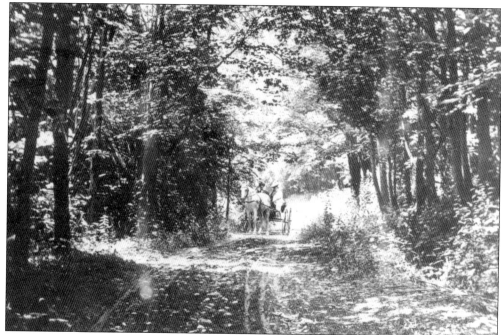

Mary Emily Shinn (1885–1970) took both of these photographs with views looking to the west along Salem Pike beyond the intersection with Sutton Road. Shinn lived at 1481 Sutton Road, a short distance away. In her later years, she recalled that her father, Thomas Shinn, gave her camera equipment when she was about 18 years old. She had hoped to leave home to attend boarding school, but that was not possible for her; she turned to photography instead. These views are precious images of the township in the early 1900s. It is said that this section of Salem Pike was once known as Lovers' Lane.

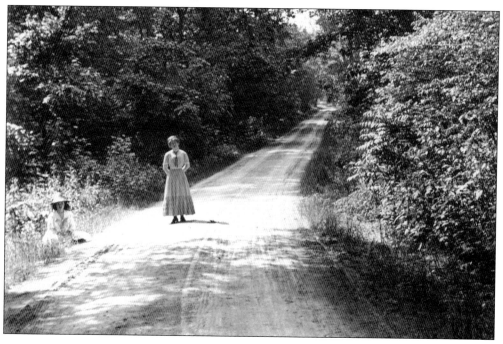

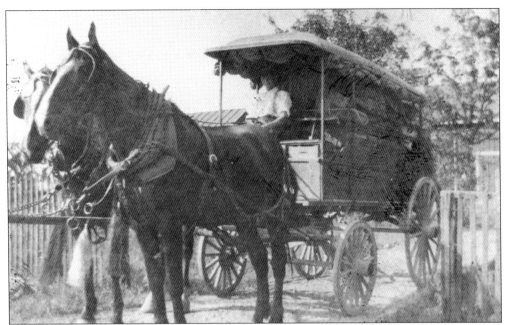

Walter W. Ayer (1852–1921) is pulling out of his 35-acre farm on State Road around 1910 in this photograph. His very large wagon appears filled with produce for market. He and his wife, Martha Mathews Ayer (1851–1932), were married about 1878 and raised four children on the farm.

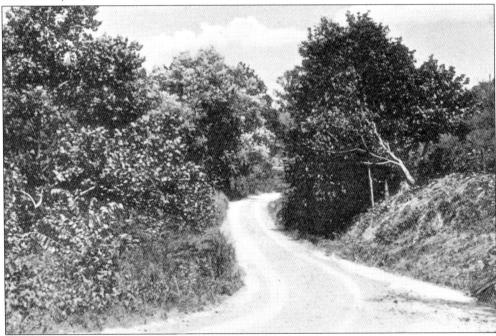

This postcard from about 1910 illustrates the rural roads of the township at the time. The view was taken looking along what was then called Bogart Road because of the Bogart families that lived along it. It winds through the valley between Beechmont Avenue and Clough Pike and is today known as Berkshire Road. A pattern of ruts is seen in the road from the wagons and buggies that traveled on it.

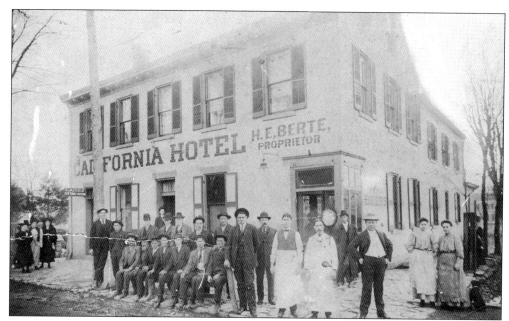

Travelers along the Ohio River used the accommodations at the hotel in the village of California. It was located at the intersection of the New Richmond Turnpike (today's Kellogg Avenue) and Rohde Street. In 1905, H. Edward Berte (1868–1920) was the proprietor. A newspaper report of the time spoke of the spacious dining room.

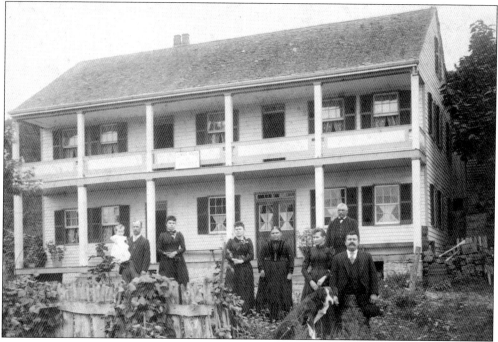

Joseph Prudent (1830–1903), who came from France in 1852, was among the local farmers who once cultivated grapes in the area of the township known as Sweetwine along the Ohio River. He operated the Twelve Mile Hotel, located on Kellogg Avenue east of Five Mile Road, for many years. Prudent (standing on the left) and his family pose in front of the hotel around 1892.

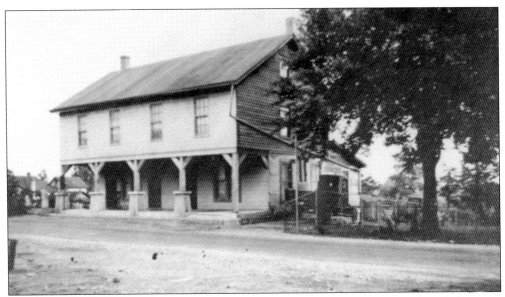

The Cherry Grove Tavern was once popular with those traveling back and forth between Cincinnati and communities to the east of Anderson. It was on Ohio Pike, today's Beechmont Avenue, near the intersection with Eight Mile Road. Legend has it that local temperance crusaders once convinced the saloonkeeper to pour out his supplies of alcohol.

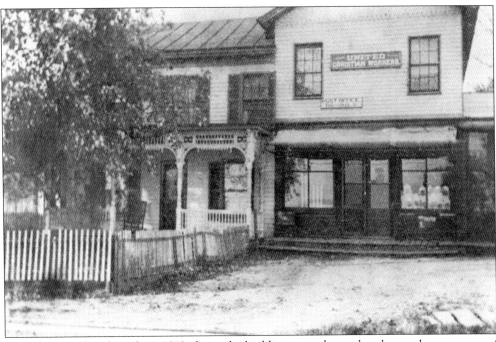

This photograph, taken about 1910, shows the buildings once located at the northwest corner of today's Beechmont Avenue and Wolfangel Road. The Forestville Post Office was in the store. The United Christian Workers met in a building in back of the one with the sign. The buildings burned in 1914, and by 1920, the corner was the site of one of Anderson's first car dealerships.

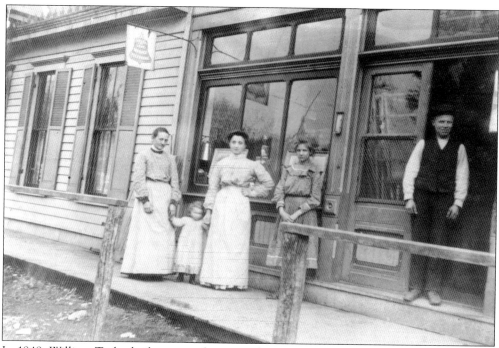

In 1848, William Taylor built a general store at the corner of today's Beechmont Avenue and Birney Lane. He planted beautiful gardens nearby, with handsome evergreen trees that people came from miles around to see. When a post office was established in the store in 1879, it was named Cedar Point. The original building burned and was replaced in the 1880s. Ben and Mary Heitel purchased the property about 1903; Ben managed the store, and Mary was the postmaster of the Cedar Point Post Office. The Heitel family are seen in these photographs, taken about 1903. A Bell Telephone sign announces that a pay telephone was available at the general store. At that time, few homes had such a modern convenience.

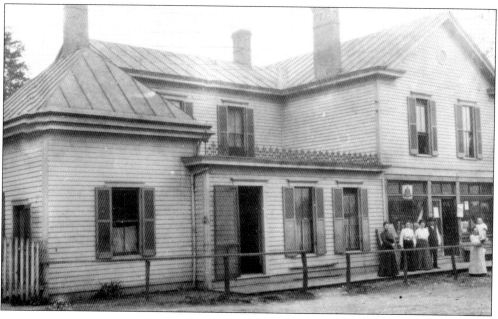

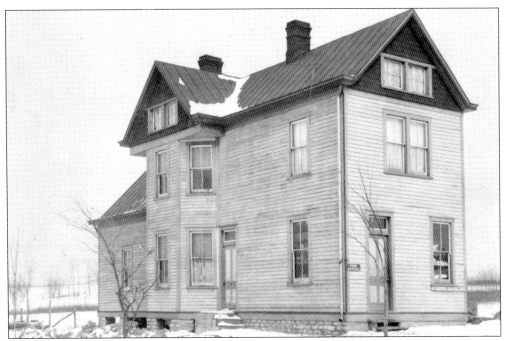

The front room of the Banks home, at the northeast corner of Clough Pike and Eight Mile Road, was a general store and the Mount Summit Post Office. Leonard R. Banks was appointed the Mount Summit postmaster in 1893, shortly before this photograph was taken. The store stocked groceries and notions. Local residents could trade excess butter and eggs for supplies.

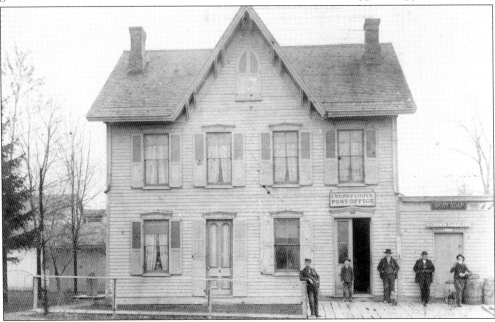

The Cherry Grove Post Office was in the grocery store operated by George Powell for over 30 years at the southeast corner of Ohio Pike (today's Beechmont Avenue) and Eight Mile Road. Powell, standing on the left in this 1906 photograph, was the Cherry Grove postmaster from 1878 to 1909.

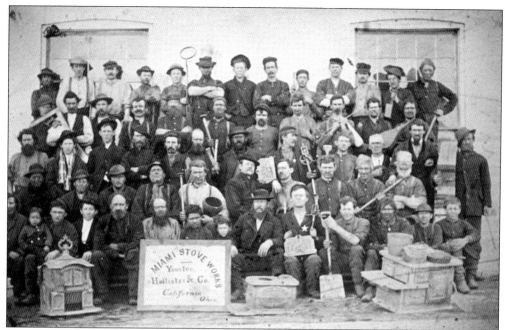

In the 1870s, the Miami Stove Works of the Yourtee, Hollister & Company operated in the village of California. This photograph shows some of the products of the company and the large number of men employed at the stove works. When the firm closed in 1878, the newspapers wrote of the financial hardship on the local community.

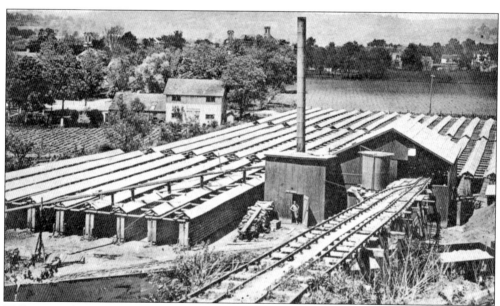

William Friedrich and his sons Oscar and Edward established the Newtown Brickyard in 1904 in the area of today's Drake Street. The clay was dug by hand before steam shovels came into use. This 1913 postcard shows the drying sheds. The tracks were used to haul bricks from the molding building. The brickyard once employed 35 to 40 men during the summers before the operation closed in 1936.

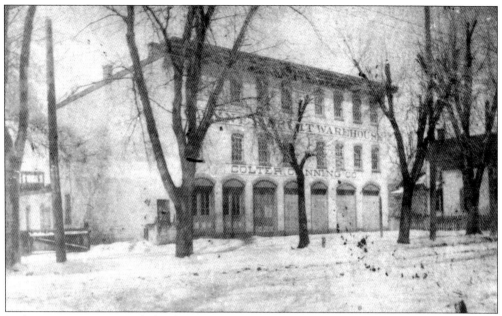

In the 1860s, Cincinnati wholesale grocer Aaron Colter moved out to Mount Washington, where he built a home. He also established the three-story brick Colter Canning Company, which operated on Beechmont Avenue in Mount Washington from the 1860s to the early 1920s. The company's specialty was tomato products, using supplies obtained from local farms.

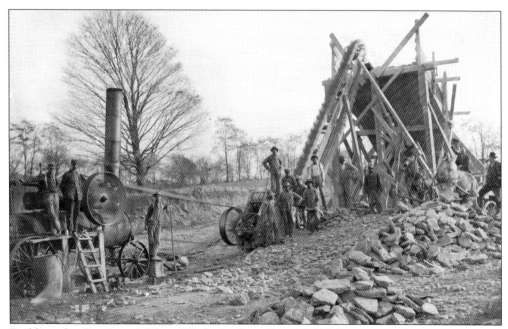

Building the Cincinnati Water Works in the village of California was a large construction project in the early 1900s. This postcard from 1907 shows a steam engine operating a conveyor that was part of the excavations for the water basins created on a hill near the Ohio River. The man standing at the left side of the image was identified as Charles Steinmetz by the family that saved the postcard.

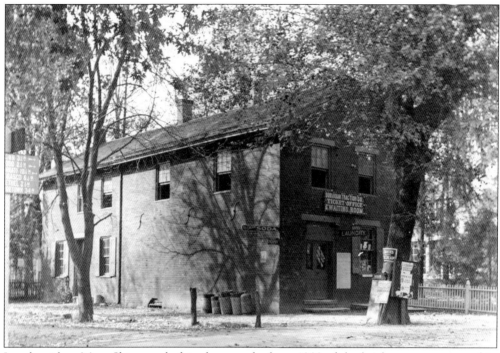

Local resident Mary Shinn took this photograph about 1908 of the brick store constructed in 1846 by Stephen Justis Sutton at what is today the northwest corner of Beechmont Avenue and Corbly Road. Sutton was appointed the local postmaster in November 1846 and renamed the post office Mount Washington.

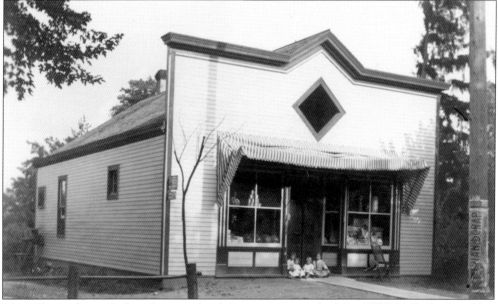

Mary Shinn also took this photograph of the grocery store built by W.W. McFarland and his brother Dan in 1905 on the east side of Beechmont Avenue. In 1927, it became the first Kroger store in Mount Washington. Kroger has greatly expanded its facilities over the decades since and continues to be a major retailer in the community.

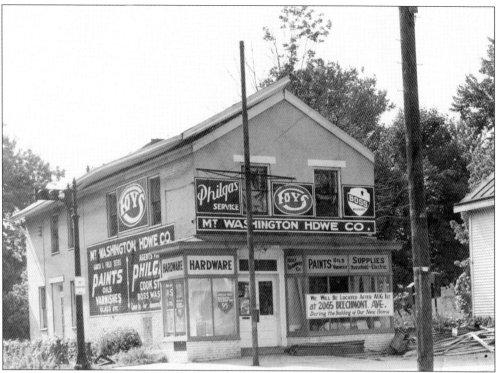

The brick store built by Stephen Justis Sutton in 1846 was occupied over the years by a variety of businesses, including a confectionery and several hardware stores. It was finally demolished about 1940. This photograph was taken when the Mount Washington Hardware Company was announcing it would be relocating during the construction of a new building.

This view looking southwest along Beechmont Avenue shows the commercial area of Mount Washington during the construction of the water tower in the 1930s. Although many of the buildings seen in this photograph have been remodeled or replaced, the Art Deco–style water tower remains a community landmark visible for miles around.

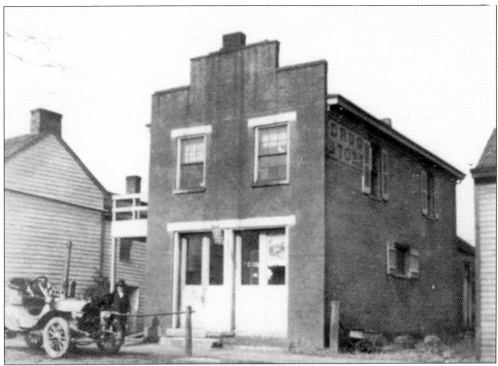

The US Post Office established local rural free delivery (RFD) service in the early 1900s. The many small post offices in the township were consolidated, with the Newtown Post Office serving those living north of and on Clough Pike and the Mount Washington Post Office serving those in the southern area. This photograph shows the Newtown Post Office on Main Street about 1916, when Mattie Ong was the Newtown postmaster.

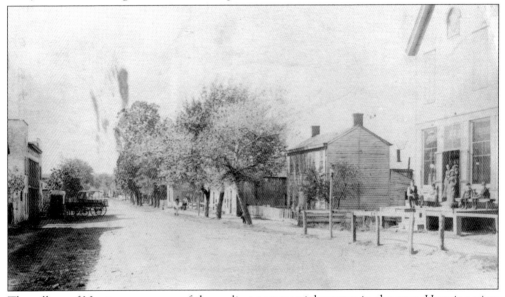

The village of Newtown was one of the earliest commercial centers in the area. Here is a view looking east along Main Street from the intersection with Church Street about 1890, when Newtown had a population of 552 people.

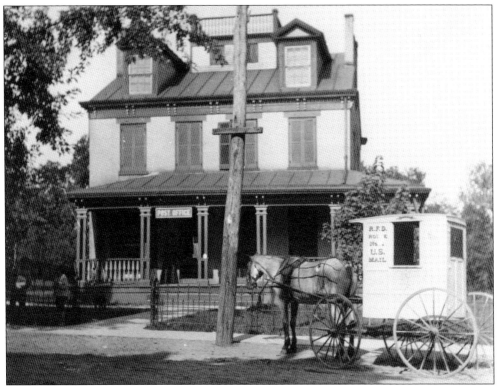

Around 1905, Mary Shinn took this photograph of the Mount Washington Post Office. Effie M. Foster was the postmaster, and the post office was located in the former home of A.A. Colter, owner of the Colter Canning Company. This location is today 2231 Beechmont Avenue, now the site of a Gold Star Chili restaurant.

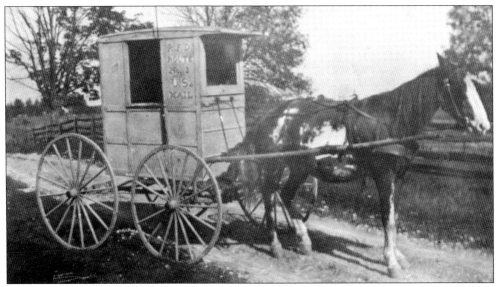

The RFD routes in the area operated from the Newtown and Mount Washington Post Offices. The service provided home delivery to those not living close to the post office. Here is the RFD Route No. 1 postman with his delivery horse and buggy on Markley Road around 1915.

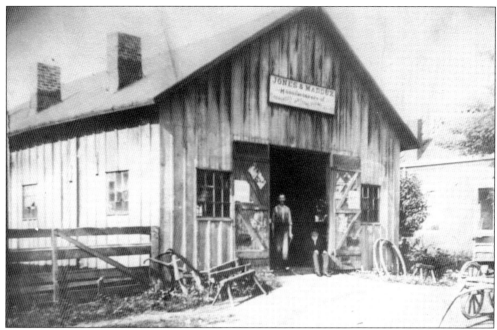

The sign reads "Jones & Maddux: Manufacturers of Carriages, Wagons, Plows & etc." The owners, William Ayer Maddux (left) and his father-in-law, John W. Jones (right), operated this very successful blacksmith shop on Beechmont Avenue west of Eight Mile Road. The shop supplied needed services to the farming community from 1872 to 1920.

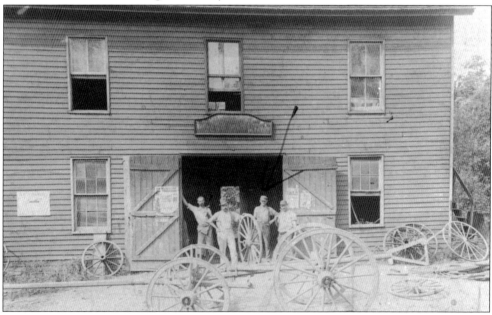

The Weil Blacksmith Shop was on Clough Pike near the intersection with today's Berkshire Road. This c. 1900 photograph is a reminder of how necessary sturdy wagons and carriages were for commerce and travel. The rough roads of the times necessitated ongoing maintenance of the equipment. Blacksmiths were kept busy year-round building and repairing the vehicles and caring for the horses that pulled them.

William J. Hammer (1852–1927) had his carriage and wagon manufacturing shop at what would be today's 8325 Beechmont Avenue, across the street from the Jones & Maddux shop. The services of these blacksmiths and carriage- and wagonmakers remained essential to the farming community throughout the early decades of the 1900s. Today, car dealerships and repair shops have taken their places along Beechmont Avenue.

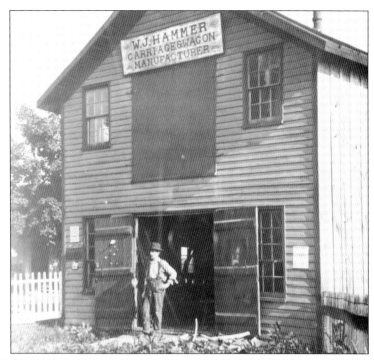

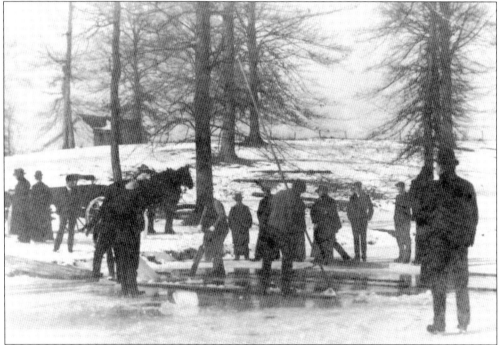

Horse teams and wagons worked year-round. Winters meant that ice could be harvested from local ponds, supplying the iceboxes of the early 1900s. This pond was once located southwest of the intersection of Beechmont Avenue and Birney Lane, behind what is now Guardian Angels School. The pond supplied water and ice to the original St. Gregory Seminary and was known as Seminary Pond to local residents.

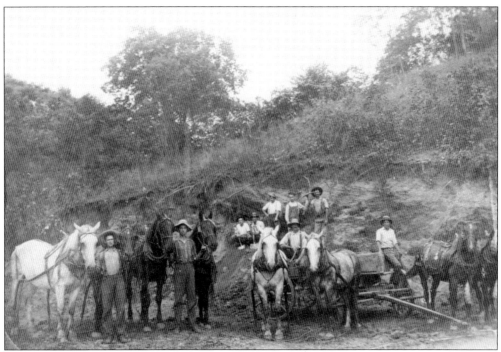

Clough Pike was one of the earliest roads in the township. It was established around 1830 as a privately operated toll road and remained a toll road until acquired by Hamilton County by 1912. The newly purchased public roadway was in need of major repairs. Local farmers Clifford and Charles Wittmeyer were hired for road construction. The crew moved soil to fill in areas where the road was washed out.

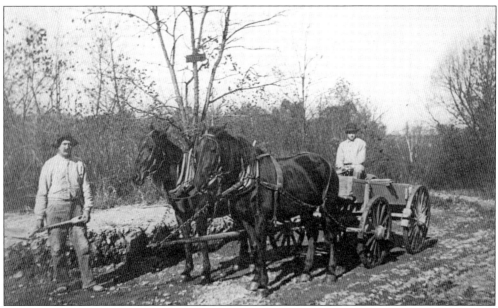

Lawrence Leuser (left) and William Kuntz are hauling gravel out of Clough Creek near the corner of Clough Pike and Bogart Road (known today as Berkshire Road) around 1915 to repair the surface of local roads. At that time, doing road repairs was a means of paying county taxes.

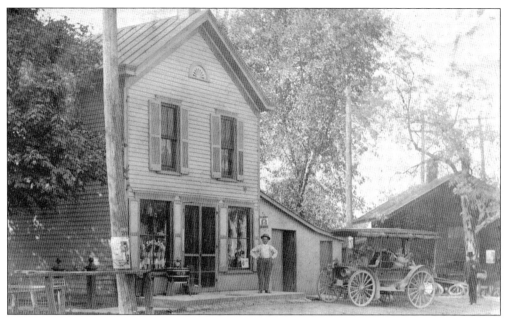

Douglas Sheldon (1850–1931) is pictured in 1913 standing in front of his hardware store at what would be 7721 Beechmont Avenue in Forestville today. He was proud of his modern International Harvester delivery truck. The shed at right was the Cincinnati, Georgetown & Portsmouth Railroad station; Sheldon was also the station agent.

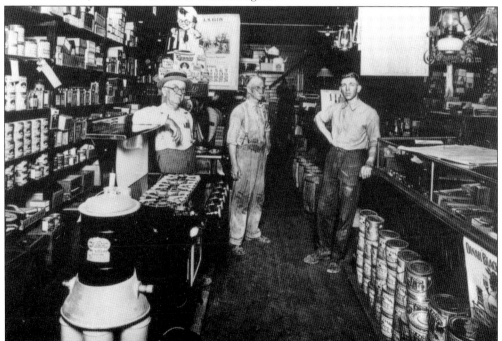

The interior of the Sheldon Hardware store is seen in April 1923. From left to right are Douglas Sheldon, Theodore Hawkins (1871–1957), and Wilbur Hawkins (1896–1986). A variety of wares was sold: cement, paints, lanterns, and teapots. Sheldon sold his store in 1927 to the Forestville Fuel and Supply Company, which remained in business for more than 40 years.

In 1915, Harry Dunn (1884–1973) took over the shop of Frank Hopper in Forestville on the north side of Beechmont Avenue, east of the intersection with today's Wolfangel Road. Hopper had operated a popular combination barbershop, confectionery, and tobacco shop with three pool tables. Dunn replaced the pool tables with a grocery store. For a while, Jim Davis joined him as a partner. The photograph above shows the buildings in the area along Beechmont Avenue around 1920. The photograph below captures the men at work moving supplies for the store in a very packed delivery vehicle.

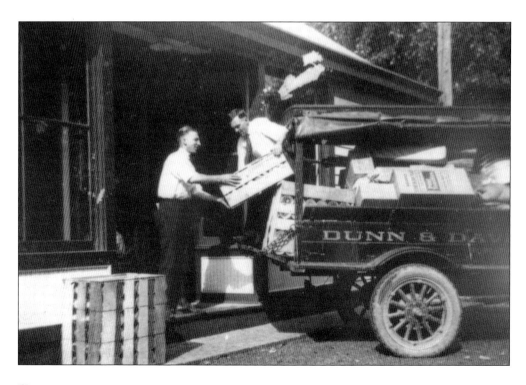

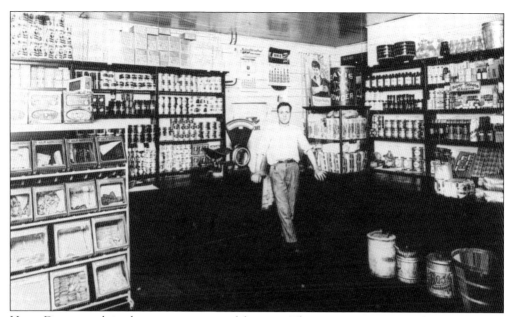

Harry Dunn stands in the grocery section of the store. There is an impressive rack of Streitmann crackers and cookies for sale. Display banners advertise "Back to Old Time Price! Kellogg's Corn Flakes" and "Bayer Tablets of Aspirin." The large calendar on the wall dates the image to June 1923.

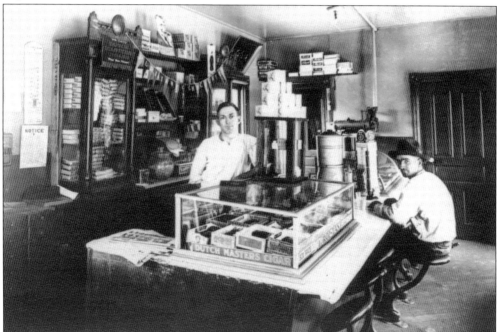

Harry Dunn's homemade ice cream was famous throughout the area. Here, Dunn is seen behind the counter waiting on a customer. One banner advertises Puritan Chocolates. The case includes many varieties of Dutch Masters cigars. Advertisements in the 1920s promised that Dutch Masters cigars were available in "seven shapely sizes" and suggested, "Smoke a Dutch Masters Cigar and listen to its crackle: it is the song of a really good cigar!"

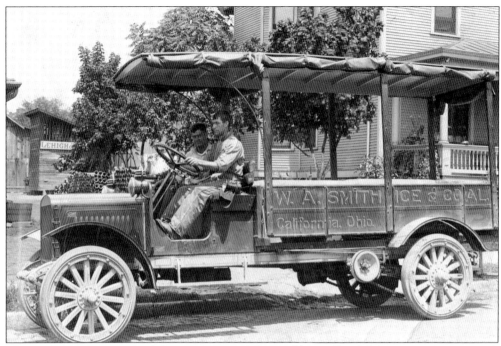

The W.A. Smith Ice & Coal Company, in California, Ohio, offered deliveries in its new truck about 1918. Pictured are William H. Hawkins (left) and company owner William A. Smith at the steering wheel. The vehicle featured a chain drive, solid tires, and side curtains.

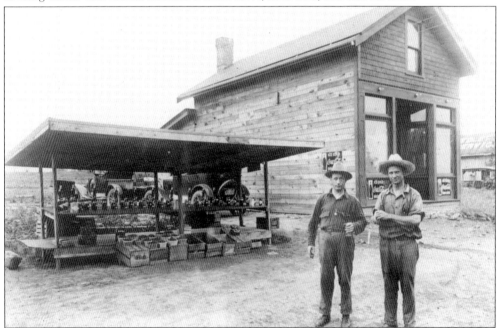

The Davis Market was located at the southeast corner of Beechmont Avenue and Salem Pike in the 1920s. Clem Davis and his son Mont Davis (1896–1976) operated this roadside stand and market beginning in 1919. Mont is the man standing on the left in this 1925 photograph. Much of the produce sold came from his nearby farm on Markley Road.

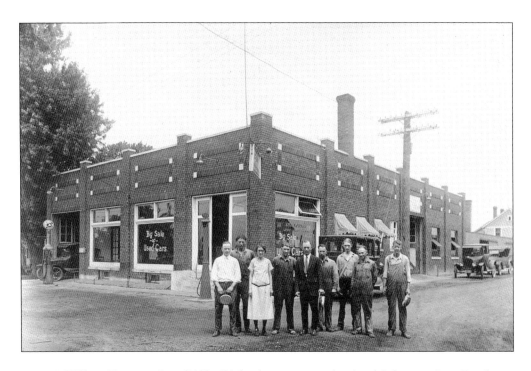

In 1916, William Emerson Ayer (1893–1936), who grew up on his family's farm on State Road near Nagel Road, opened one of earliest—probably the first—car dealerships in the township. The Ayer Motor Car Company was at what is today the corner of Beechmont Avenue and Wolfangel Road. The company handled Ford cars and trucks and Fordson tractors. A report from 1920 describes how Ayer built "a modern structure, fully equipped to care for every angle of the business." Pictured above around 1923 are, from left to right, John Riggs, Gene Boggs, Hazel Johnson, Art Turton, George Glaub, Walter Ayer, Lloyd Bridges, Wilbur Wolfangel, and Red Hardy. The Glaser Wilson Ford dealership later occupied this location for many years.

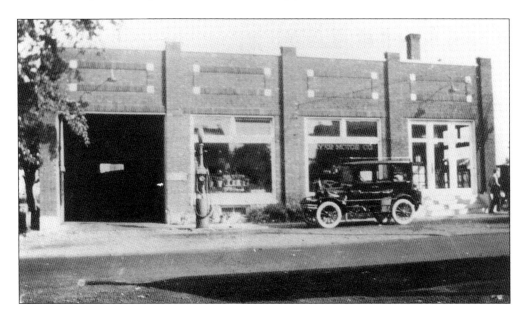

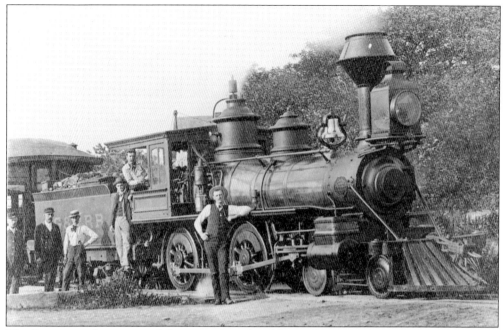

The Cincinnati, Georgetown & Portsmouth Railroad (CG&P) had its first run in September 1877. The line ran from the Carrel Street station in Cincinnati's East End, over a Little Miami River bridge, up the steep hillside to Mount Washington, and then cross-country through Anderson out to Mount Carmel. Eventually, the line extended to Georgetown, but it never reached Portsmouth.

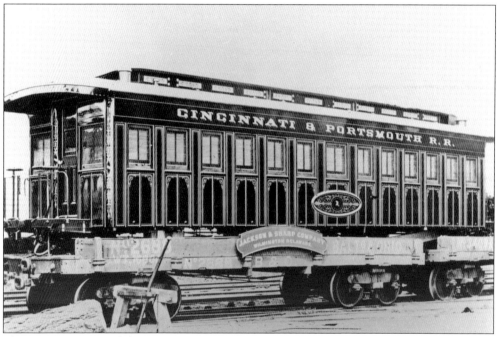

The CG&P was named the Cincinnati & Portsmouth Railroad when it was first organized in the 1870s. This 1877 photograph shows the handsome passenger Coach No. 1, built in Wilmington, Delaware. It is resting on a flatcar for delivery to be put into service on the new railroad line.

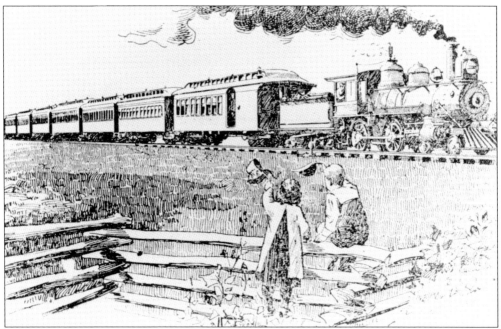

This illustration appears in a booklet published by the CG&P in 1898. It is an artist's fanciful sketch; the CG&P's steam locomotives of the time could not pull more than three cars up the steep grade from the Little Miami River to Mount Washington. By 1902, the CG&P had changed to standard-gauge rails and electric-powered equipment.

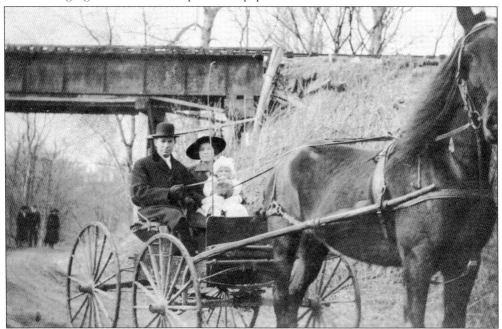

In 1915, Charles Duckett, his wife, Stella, and their young daughter Alice pose on Salem Pike. The trestle of the CG&P crossed over Salem Pike about a fifth of a mile west of the intersection of Salem Pike and Eversole Road. After the CG&P closed in 1935, the trestle was removed, Salem Pike was raised, and sharp turns in the road were eliminated.

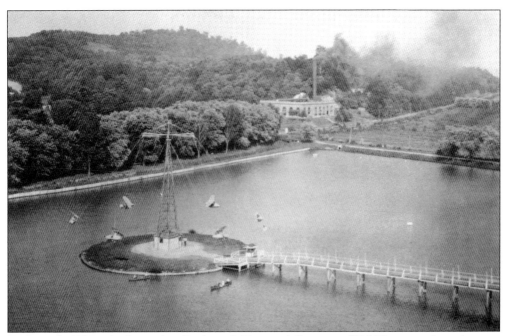

In the early 1900s, the Interurban Railway & Terminal Company (IR&T) operated two lines in Anderson: the Suburban Division, described as a "32-mile ride through Ohio's best fruit belt" to Bethel, and the Cincinnati & Eastern Division, a 20-mile scenic route along the Ohio River to New Richmond. The powerhouse, located across from Coney Island, generated electricity for both. This c. 1906 photograph shows smoke pouring from the station.

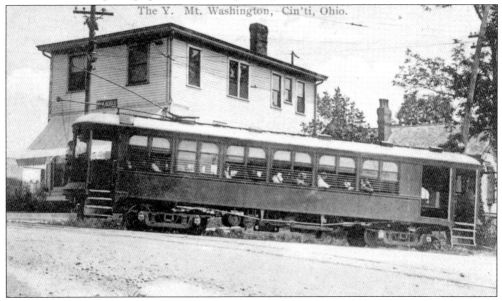

The Suburban Division left the Eastern Division at Kellogg Avenue, followed Sutton Avenue to Mears Avenue, and ran up Mears Avenue and along Ohio Pike (today's Beechmont Avenue) in the township out to Bethel. This postcard, from about 1915, shows a car at the Y-shaped intersection of tracks at Beechmont and Mears Avenues. Cars pulled up onto Beechmont Avenue and then backed down a short length of track to the station in Mount Washington.

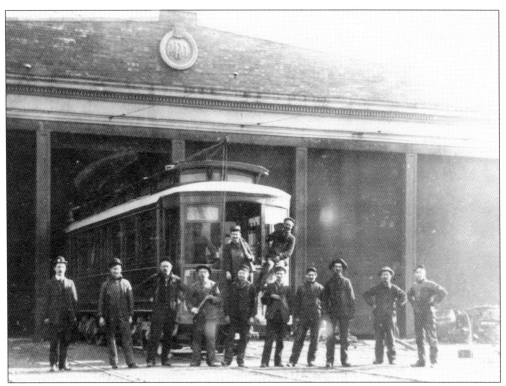

The IR&T had a carbarn on Kellogg Avenue opposite Coney Island. This rare photograph shows some of the operators and service personnel of the company. The IR&T was often called the "Black Line," because the cars were painted a dark Pullman green and looked black to most people.

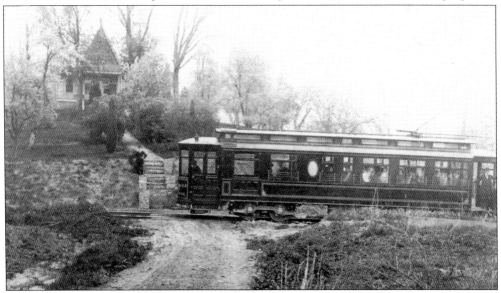

This IR&T car is stopped near the intersection of Eight Mile Road and Kellogg Avenue in 1903. The conductor is standing on the rear platform of the car, the motorman is at the controls, the passenger compartment appears full, and there are two men in the baggage compartment near the front of the car. The oval window marks the small toilet room.

65

In this view looking northwest on Beechmont Avenue from Birney Lane around 1910, the tracks of the IR&T run along the south side of the road. The Guardian Angels Church buildings are visible in the distance. The fence encloses the property of St. Gregory's Seminary.

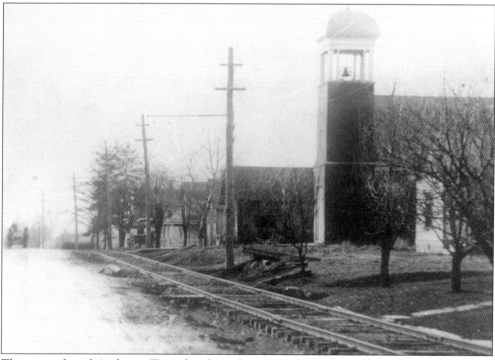

This view of rural Anderson Township from about 1910 shows the tracks of the IR&T running west along Beechmont Avenue from near the intersection with Eight Mile Road. The Cherry Grove Evangelical United Brethren Church of Anderson is seen on the north side of the tracks. Beyond the church is the Jones & Maddux blacksmith and carriage shop.

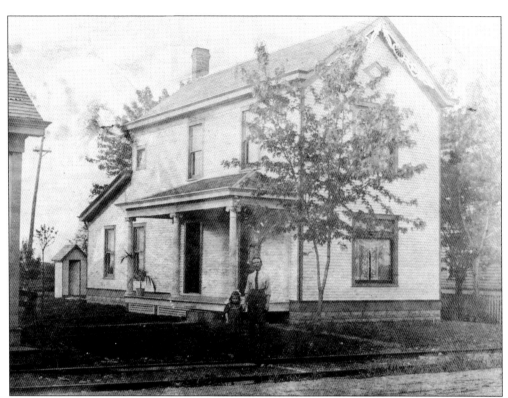

The tracks of the electric
Suburban Division of the IR&T
ran along Ohio Pike, today's
Beechmont Avenue, after the
railway line left the Mount
Washington area. A 1910
schedule shows more than 14
daily trips each way from the
terminal station in Cincinnati
on Sycamore Street out to
Bethel. The Suburban Division
operated from 1903 to 1918,
when the tracks were removed.

In the winter of 1917–1918, Van and Catherine Johnson wait for a trolley to Cincinnati. The tracks of the two interurban lines crossed at this point. The IR&T ran along Beechmont Avenue, and the CG&P crossed Beechmont Avenue. The wires delivering power to the two railways are seen crossing overhead.

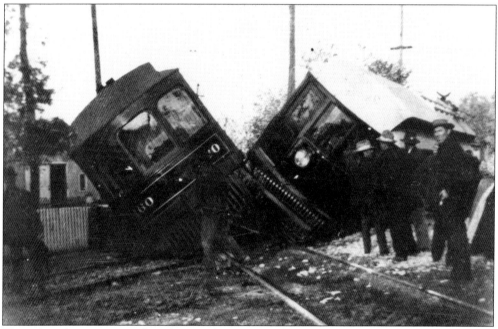

The railway lines intersected at what is today 7736 Beechmont Avenue. In 1910, the CG&P's post office car and the IR&T's express car, both headed to Cincinnati, collided. The CG&P's motorman lost the end of a finger, and vegetables carried as freight on the IR&T car scattered across the road. A neighbor, Cindy Johnson Ayer, took her box camera and recorded the unusual scene.

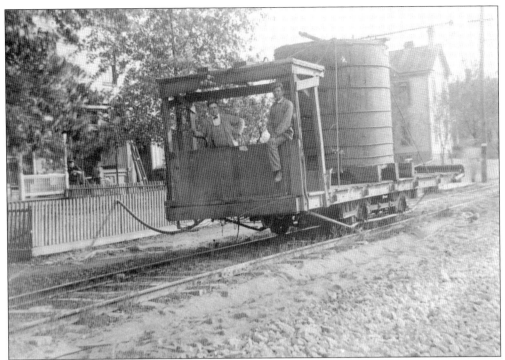

In the dry summer months, the tank and sprinkler car of the electric Suburban Line of the IR&T delivered water to local residents along Beechmont Avenue. This c. 1910 photograph shows a hose connection filling the cistern of the house with the picket fence. The tank car also sprayed water to keep down the clouds of dust along the railway's tracks.

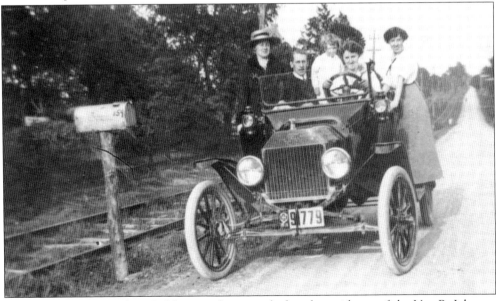

This Ford Model T with a 1915 license plate is parked at the residence of the Van R. Johnson family on Beechmont Avenue, near today's intersection with Collinsdale Avenue. The view is to the east, showing fields and the tracks of the IR&T line running along the road. Today's view would show the busy, highly developed intersection of Beechmont Avenue and Five Mile Road.

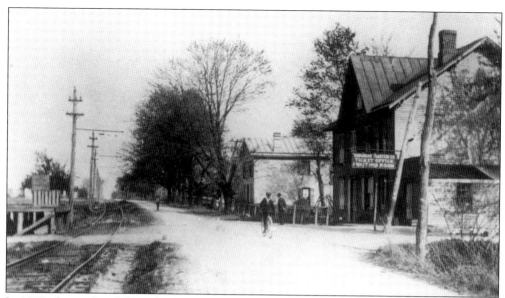

In 1912, the tracks of the Suburban Line of the IR&T ran along the north side of Ohio Pike, today's Beechmont Avenue, at the intersection with Eight Mile Road. The boy on the bicycle is Harold Z. Maddux, who lived nearby. Today's Maddux Elementary School is named to honor his long career as a teacher and principal in Anderson schools.

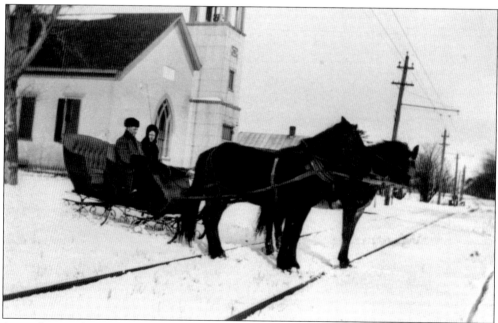

Around 1916, John Garret Van Saun and Elda Maddux are well equipped for winter travel on snowy roads. The team of horses is standing on the tracks of the IR&T on Beechmont Avenue near the Cherry Grove United Brethren Church, just west of the intersection with Eight Mile Road.

Four

EARLY COMMUNITY CHURCHES

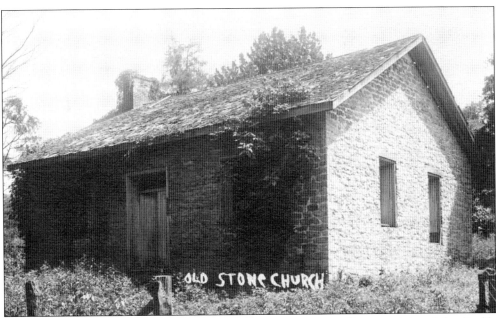

The Clough Baptist Church was organized by the young itinerant Baptist minister John Corbly in 1802. After the first wooden church burned in 1820, the congregation built this stone church along Clough Creek near today's Bridges Road. The "old stone church" became a meeting place for various church groups in the 1800s. In 1905, when this photograph was taken, the building was not in active use.

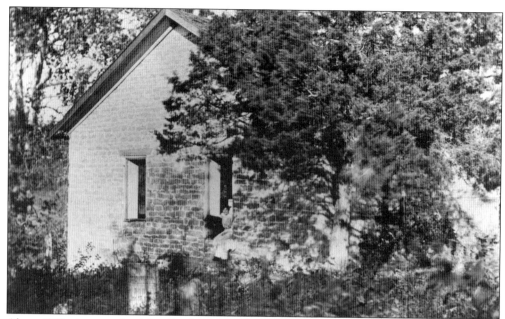

About 1907, photographer Mary Emily Shinn and her friend Olive McFarland McGilliard explored the abandoned Clough Baptist Church and burying grounds along Clough Creek. At that time, the roof and walls of the old stone church were still intact. Pieces of wooden furniture remained in the building. A local young man, P. Mergler, had scribbled his name on an interior wall. The graveyard was overgrown but the gravestones in the photograph are standing upright, including the marker of pioneer Stephen Sutton, who was born on December 15, 1760, and died on September 12, 1846. Sutton built one of first log houses in the Anderson area in 1795.

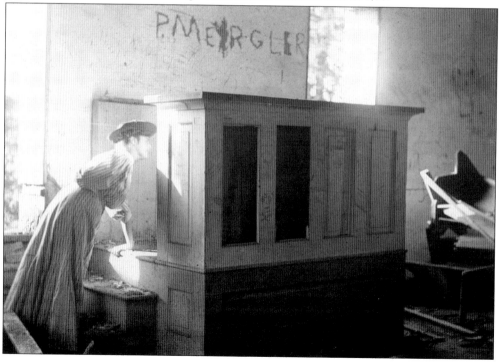

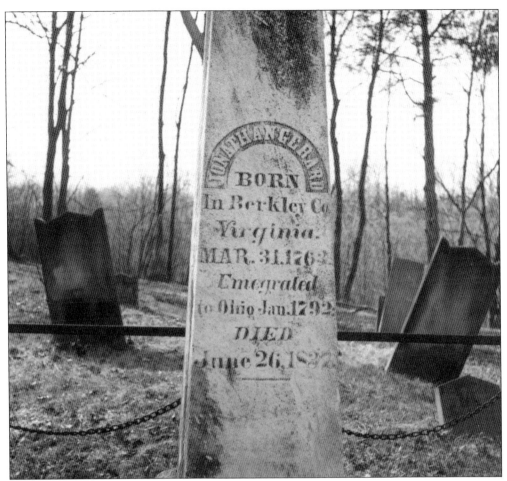

By the mid-1930s, the roof and walls of the Clough Baptist Church building had collapsed. In 1951, the building's stones were removed and used in the construction of the Methodist Community Church in California, Ohio. The graveyard adjacent to the Clough Baptist Church remains and is now owned and maintained by Anderson Township. Some of the earliest settlers of Anderson are buried there. Rev. John Corbly, who organized the Clough Baptist Church in 1802, died when he was only 46 years old in 1814 and was buried in the churchyard. Other burials include the Revolutionary War soldiers James Clark, Stephen Davis, Stephen Sutton, and Jonathan Gerard. The tall obelisk in the center of the burial grounds was erected for Jonathan and Leah Gerard by their children. Jonathan and Leah Gerard (also spelled Garard) came to Ohio in 1792 to join relatives at Garard Station on the Little Miami River. Another prominent monument in the burial grounds marks the gravesite of notable pioneer James Clark (1765–1852); his inscription includes the information that he "emigrated west in 1797."

This engraving, titled *The Grave of McCormick*, was published in the March 1860 issue of the journal *Ladies Repository*, published in Cincinnati. It depicts the Salem Methodist Church, founded by Rev. Francis McCormick (1764–1836) in Anderson Township. Reverend McCormick first held services in his home. He then built a log church building that was replaced in 1828 by the brick church seen in the engraving.

In 1863, a new Salem Methodist Church building was constructed. Bricks from the older church were used as part of the educational building next door. Mary Shinn (1885–1970), a descendant of Rev. Francis McCormick, was an active member of the church her entire life. About 1908, she set up her camera equipment so that she could appear in her photograph of the church.

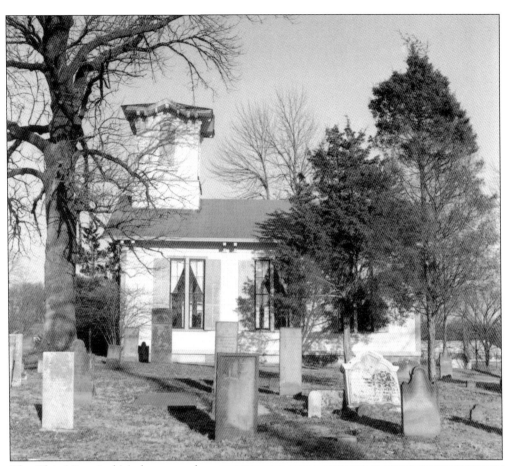

The Ohio Historical Marker erected at the church in 1969 reads: "Francis McCormick (1764–1836), who fought under Lafayette at the siege of Yorktown, founded Methodism in the Northwest Territory. His evangelical and pioneer spirit led him from his Virginia birthplace to establish churches in the wilderness, first at Milford, Ohio, then here at his village of Salem. He rests with his family and followers in the nearby church yard." McCormick's gravestone (right) has remained in excellent condition. The Salem Methodist Church, with its graveyard and educational building, was added to the National Register of Historic Places in 1982. Today, the Salem Community Church offers services in the expanded church building at 6137 Salem Road.

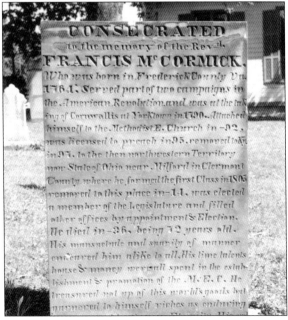

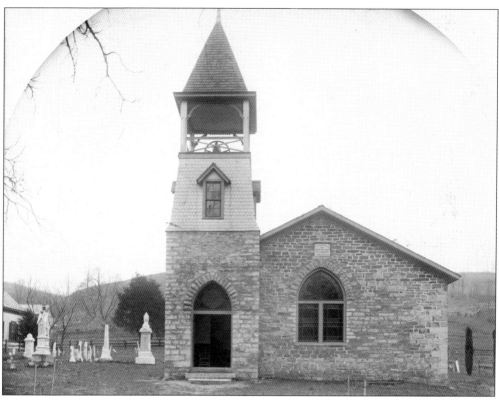

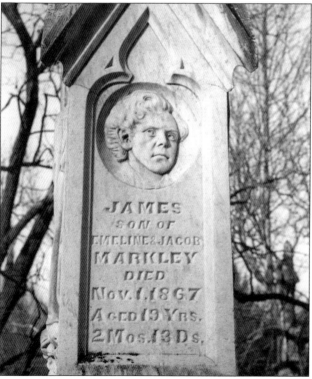

JAMES
SON OF
EMELINE & JACOB
MARKLEY
DIED
Nov. 1, 1867
AGED 19 YRS.
2 Mos. 13 Ds.

In 1844, Jacob Markley donated the land for the church and cemetery along Five Mile Creek. It was the earliest Church of the United Brethren in Christ congregation in southeastern Hamilton County. The stones for the building came from the nearby creek and hillsides. The bell tower and entrance were added in 1896. In this early-1900s photograph, the hills beyond the chapel are open fields. One of the prominent monuments standing in the cemetery remembers the family of Jacob and Emeline Markley, including their young son James, who died in 1867 at the age of 19. The church and cemetery were entered in the National Register of Historic Places in 1978. Today, the property is owned and maintained by the nonprofit Five Mile Chapel Society.

The Asbury Society was organized in Anderson about 1827. Members first met in their homes and then in a schoolhouse on Eight Mile Road. The society was named in honor of Bishop Francis Asbury, the first Ohio bishop of the Methodist Episcopal Church. Around 1835, this frame church was built on what is now called Forest Road and dedicated as the Asbury Methodist Episcopal Church. The area around the church became known as Asbury; a nearby street was named Asbury Road. In 1921, a larger building on Beechmont Avenue was purchased and the small building was razed. The cemetery on the hill above the church remained and is now owned and maintained by Anderson Township. Since the building on Beechmont Avenue had formerly been a power substation for the IR&T, the church was known locally as the "Power House Church." In the 1950s, land was bought at the corner of Beechmont Avenue and Forest Road and the construction of new facilities was begun. The name of the church officially became the Anderson Hills Community Methodist Church.

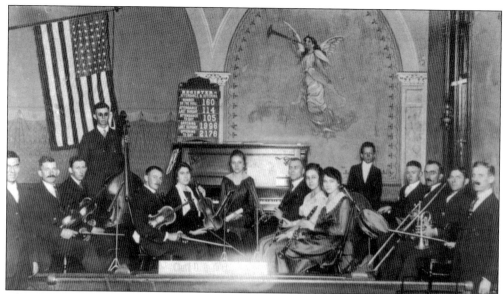

About 1864, the Cluff Mission was founded in Anderson by the German United Brethren Church. The group first met in the old stone Clough Baptist Church and then in a small schoolhouse near Clough Pike and State Road. A new brick church was completed on the site in 1886. The Cluff United Brethren Orchestra of about 1915 is pictured above; the register display in the photograph shows an "attendance to-day" of 105. On a windy Sunday in March 1920, the furnace overheated and sparks set the belfry ablaze. The interior of the church was consumed by the fire; only the walls remained, pictured below. Plans for a new building on the site were quickly made. The bricks of the old walls were collected, cleaned, and used again.

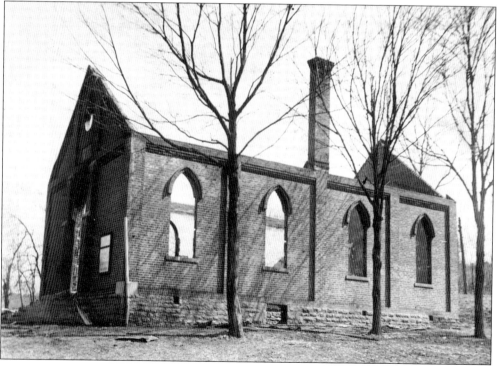

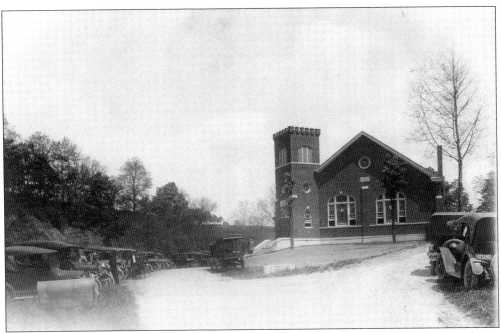

The congregation rallied; funds were raised for rebuilding within the year. This photograph was taken on May 8, 1921, dedication day for the new church building at the junction of Clough Pike and State Road. The new church could seat 500 people; it was filled three times on dedication day. Cars parked next to the church and on Clough Pike.

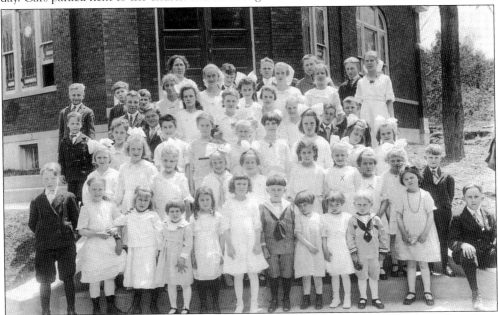

This photograph is dated June 1924 and shows Children's Day at the Clough United Brethren Church. The church building at Clough Pike and State Road remained in use until the 1960s. In 1962, the growing Clough congregation bought 14 acres at the corner of Clough Pike and Wolfangel Road. The Clough United Methodist Church, as it is now known, moved to its new church building and facilities there in 1968.

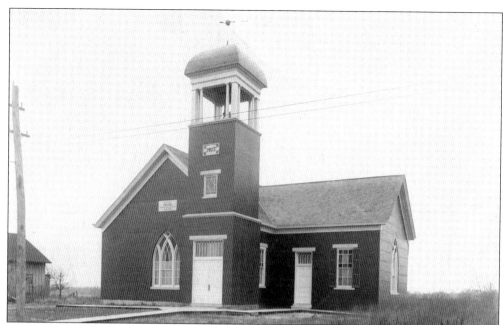

The Cherry Grove Evangelical United Brethren Church of Anderson celebrated its centennial in 1952. Early records indicate that church members first met in a nearby hotel and then in an old schoolhouse. In 1854, the first church building was constructed at what is now the northwest corner of Beechmont Avenue and Eight Mile Road. The bell tower was added in 1903. The photograph above shows the building after it had been repaired following damaging heavy winds in May 1905. In July 1915, tornado winds again struck Anderson in several locations. The photograph below shows some of the damage suffered by the church building in this windstorm. Church histories recall that the church members "carried on through dark days, as well as sunny weather." The church building was rebuilt.

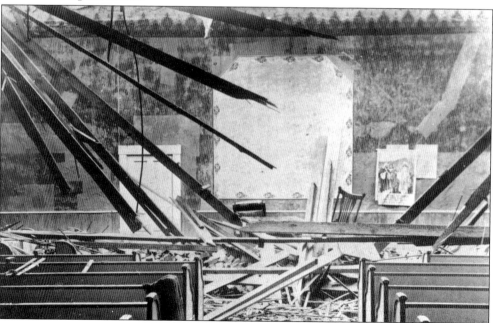

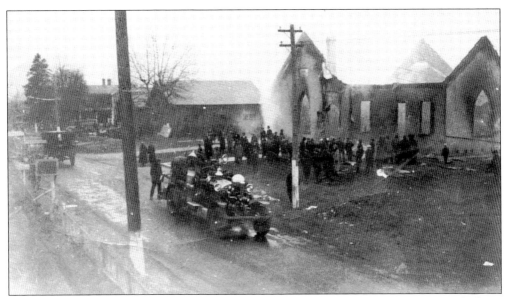

Early on Sunday, December 14, 1924, a fire destroyed the church building. The photograph shows fire equipment from the city of Cincinnati on the scene along with a crowd of churchgoers. With the loyal cooperation of church members and friends, plans were immediately made for rebuilding on same site near the corner of Beechmont Avenue and Eight Mile Road.

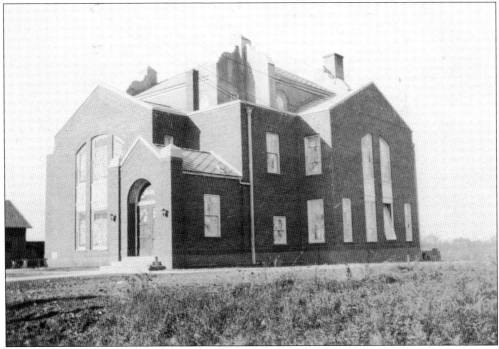

On November 22, 1925, less than a year after the fire, a new, modern church building was dedicated. This building, seen here, served the congregation well for more than four decades. In 1969, the Cherry Grove United Methodist Church, as it is now called, moved to expanded facilities at 1428 Eight Mile Road. The handsome 1925 building is now the location of McCall's Flooring at 8342 Beechmont Avenue.

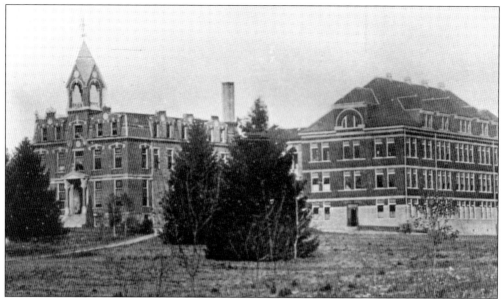

St. Gregory's Seminary, on Beechmont Avenue, is illustrated in a 1903 brochure published by the CG&P. The seminary purchased land in Anderson Township in 1890 and moved out to the countryside from Price Hill after the construction of the buildings. A nearby CG&P station was located at Cedar Point, the corner of Beechmont Avenue and Birney Lane.

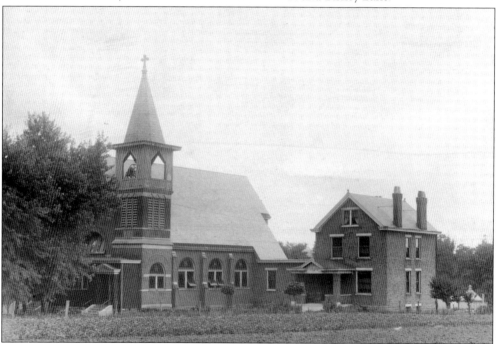

The Guardian Angels Parish in Anderson was established in 1892 to serve local Catholic families. They attended services at the seminary chapel until the first Guardian Angels Church was built. This photograph shows the church and parish house in 1910. As the parish grew throughout the 1900s, these buildings were replaced. The current church building, at 6531 Beechmont Avenue, was dedicated in 1971.

The Fruit Hill Methodist Protestant Church was chartered in 1830 and was once on Salem Pike about a half mile west of the intersection with Beechmont Avenue. The photograph at right shows the new church building constructed at the corner of Beechmont Avenue and Paddison Road in 1908. The original bell from the older building was carefully moved to the new church. Church members later wrote of the sound of the bell, remembering how it rang for church services morning and night. At funerals, it was rung once for each year of the departed's life. Some members of the church families, including the Ayers, Barths, Bennetts, Bogarts, Johnsons, Hoppers, Kendalls, Mettes, and Wests, join together around 1920 on the entrance steps for the photograph below. The church, sometimes known as "Old Bethesda," closed in 1961.

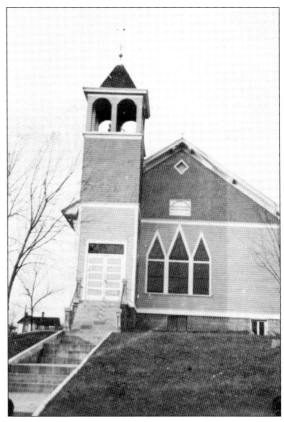

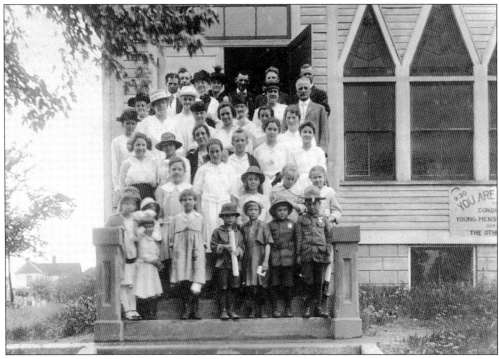

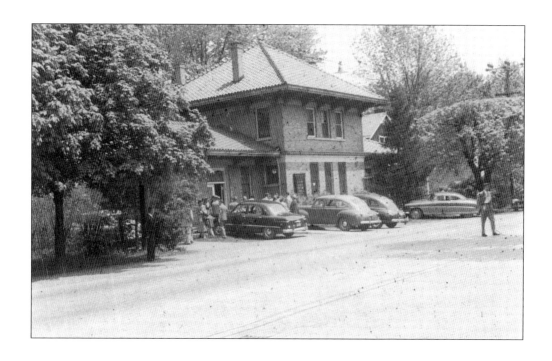

These two photographs show the Power House Church, on Beechmont Avenue opposite the intersection with Asbury Road from 1921 to 1950. The congregation of the Asbury Methodist Episcopal Church on Forest Road bought the abandoned power station of the IR&T and remodeled it for church use. Some 130 members of the church gathered for a portrait on Rally Day in 1932. In 1950, the church bought land to the west on Beechmont Avenue and the Power House Church site was sold. Today, the Anderson Hills United Methodist Church, as it is now known, continues to grow at its prominent location at the corner of Forest Road and Beechmont Avenue.

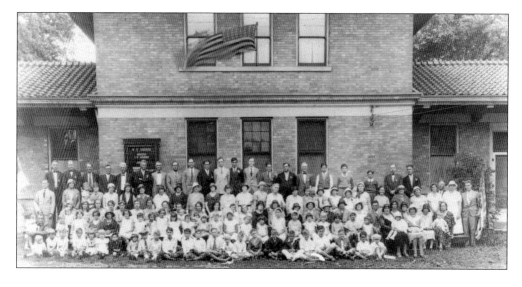

Five

SCHOOL BELLS RING

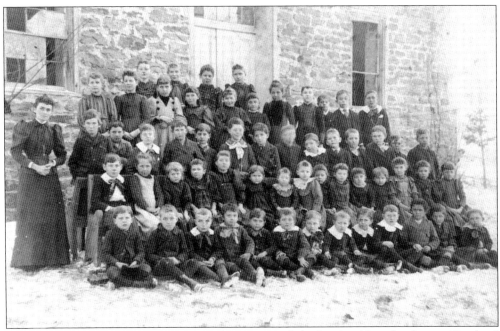

In 1826, the trustees of Anderson Township organized the local public schools into 12 school districts. Throughout the 1800s, new and additional schools were built in the township. Schools offered classes from the first to eighth grades. About 1885, the students attending the District 7 School on Clough Pike walked over to the nearby old stone Clough Baptist Church to pose for their school photograph.

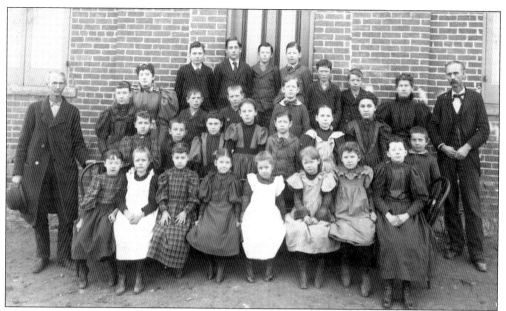

The District 5 School was in the brick building next to Salem Methodist Church at Salem Pike and Sutton Avenue. This 1894 school photograph includes students from 15 local families. The adults are truant officer Leonidas Johnson (far left) and teacher Everett Bennett (far right).

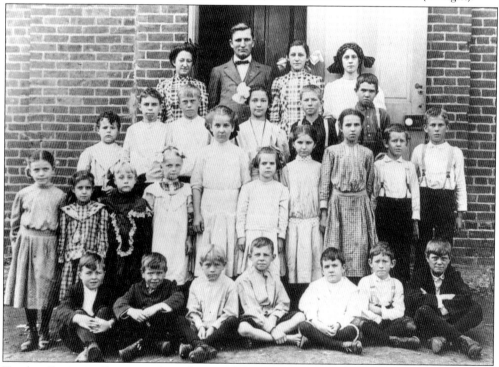

Teacher Benjamin Fiscus stands at the top of the steps between sisters Nellie (left) and Bertha Shannon in this photograph at the Salem District 5 School around 1908. The children represented 14 local families, including three Burnes brothers, three Lanter brothers, and the Shannon sisters' younger brother and sister.

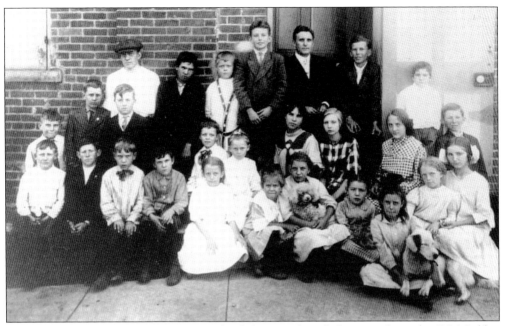

Taken about 1913, this Salem District 5 School photograph includes not only teacher B.J. Maddux and his pupils but also two family dogs. It is said the large dog in the first row on the right came to school every day for nine years, along with the six Shannon children.

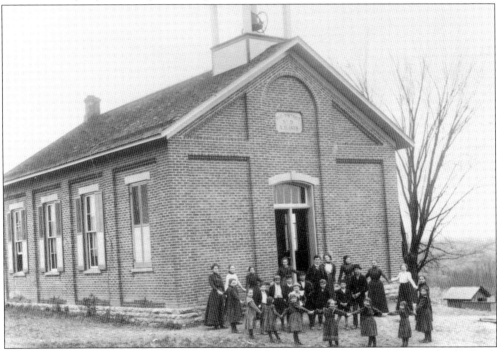

The District 9 School was near the intersection of Little Dry Run and Bridle Road. The brick schoolhouse was one of several new schools built in the 1870s. This rare photograph from about 1903 shows the pupils posing as they play. The school closed in the early 1900s because of a shortage of pupils living nearby.

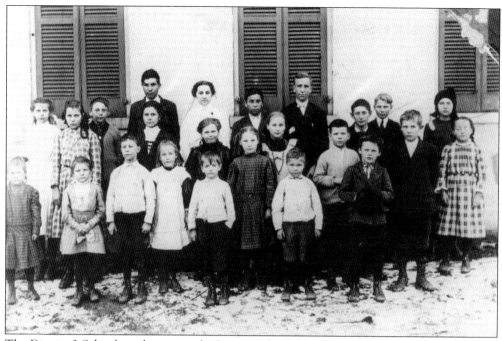

The District 3 School was known as the Lower Eight Mile School and was on Eight Mile Road south of Hopper Road. In 1911, teacher Pearl Winn (back row, fourth from left) and her 23 pupils from 14 families pose for a school photograph. In the 1920s, the district was discontinued because the number of students had dropped below the number required by law.

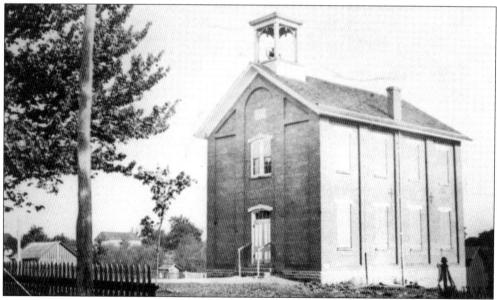

The District 4 School was at the intersection of Beechmont Avenue and Eight Mile Road and was known as the Cherry Grove or Upper Eight Mile School. This 1890s photograph shows that it was one of the larger two-story brick schools built in the late 1800s. The tornado-strength winds of the "Great Storm" of July 7, 1915, destroyed the building.

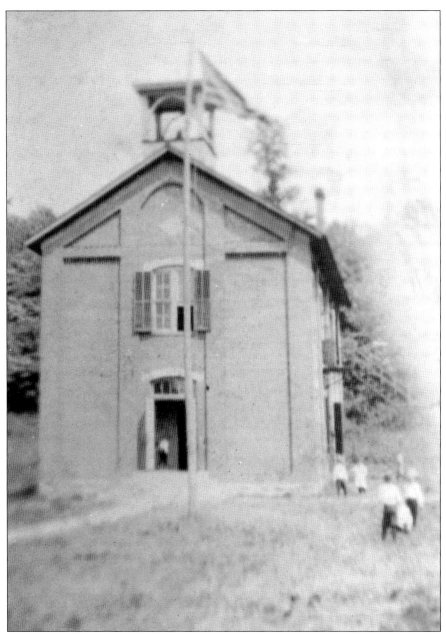

In 1874, the District 7 School, or Clough School, was built on Clough Pike opposite the intersection with today's Berkshire Road. This photograph from about 1910 shows the two-story brick school building with its bell tower and tall flagpole. The sound of the school bell called pupils from along Clough Valley to class for more than five decades. In 1929, Anderson Township opened one central school on Beechmont Avenue. Clough School and the other district schools were closed. The Clough School building was used by the Mount Washington American Legion Post 484 for some years, and in 1943, it was converted into a tavern by local businesswoman Flora Hess. She operated her popular pub at this location for 40 years. Although the bell tower has been removed, the building is remarkably well-preserved. It has been the home of Clough Crossings Restaurant since 1997.

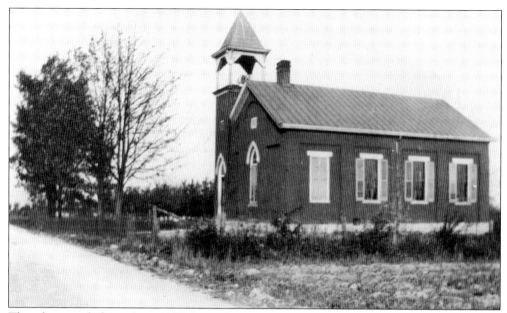

This photograph from about 1895 shows the Mount Summit District 8 School. The fine brick school was constructed in 1891 on Clough Pike east of Nagel Road. An earlier school at the site had been destroyed by fire. Specifications for the new building called for the best galvanized lightning rods to be installed.

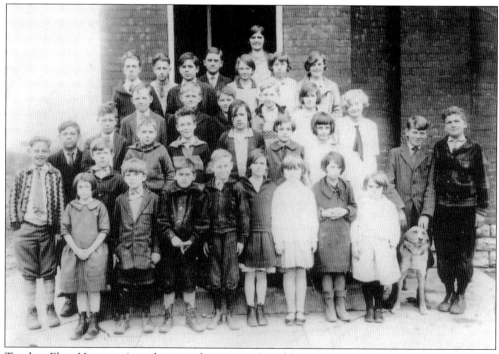

Teacher Elsie Harmon (standing on the top step) and her pupils at Mount Summit District 8 School pose for a school photograph in 1928. A family dog is also included in this school portrait. Most of these students went on to attend the centralized Anderson School when it opened in the fall of 1929.

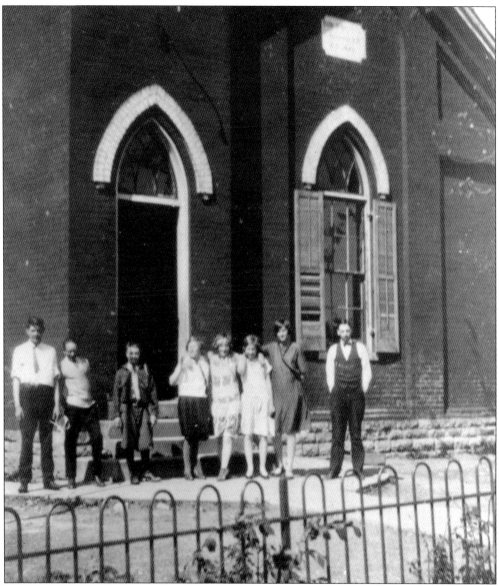

Harold Z. Maddux (1898–1995) was the sole teacher at Mount Summit School from 1925 to 1927. This photograph shows Maddux and seven students who graduated from the eighth grade at the Mount Summit District 8 School in 1927. From left to right are pupils James Dube, Robert Staub, Clyde Ingram, Catherine Staub, Annamae Pryor, Viola Moore, Angela Merz, and teacher Harold Z. Maddux. Maddux taught in the Anderson school system for many years and served as principal of the Anderson Elementary School from 1952 to his retirement in 1969. In later years, he recalled his years of teaching all subjects to some 65 pupils in eight grades in a one-room schoolhouse. He remembered that the first graders sat in one row, the second graders sat in the next row, and so on. Today's Maddux Elementary School was dedicated in his honor in 1966.

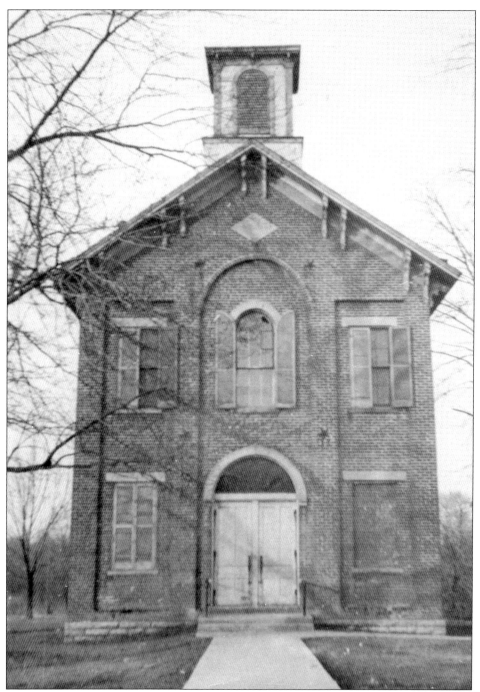

The Fruit Hill District 13 School was built about 1870 and stood on the north side of Beechmont Avenue across from the intersection with Salem Pike. It was one of the two-story brick school buildings from the 1870s that served the community for many decades. It once had the nickname "Spiderweb College" for reasons that can only be imagined. Those who attended the school recalled that the first through the fourth grades met on the first floor, and the fifth through the eighth grades used the second floor. The teacher of the higher grades served as the school principal.

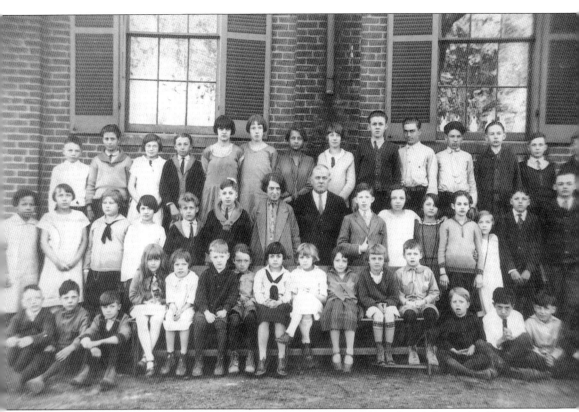

Pictured at the Fruit Hill District 13 School in the spring of 1925 are, from left to right, (first row) Charles Duckett, unidentified, Bob Ludlow, Cathryn Walls, Ruth McMullen, two unidentified, Mildred Riggs, Bernice Dunn, two unidentified, Dale Pluedemann, Fred Daugherty, Morton Fehn, Morris Dunn, and unidentified; (second row) Catherine Hill, Gladys Vogelsang, Luella Judd, Rosemary Linder, Hubert McMullen, Francis Buchanan, Mrs. Beagle (teacher of grades one to four), Harvey Markley Van Saun (school principal and teacher of grades five to eight), Robert Whitaker, Alice Duckett, unidentified, Helen Metz, Ruby Kuntz, LeRoy Witschger, and Lloyd Kendall; (third row) George Richardson, Bill Ludlow, Eva Johnson, David Daugherty, Marie Greer, Ruth Wittmeyer, Dora Hill, Alma Linder, Carrol Johnson, Lewis Rath, Lester Dunn, Louis Merz, Daniel Linder, and Dale Kendall. After the township opened one central school in 1929, the Fruit Hill school building was used by commercial stores. In the 1960s, the store was called the Handy Pantry. The building was razed in the 1970s.

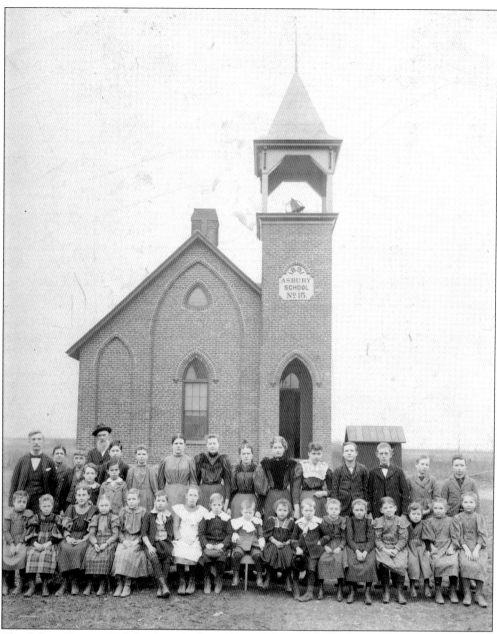

The Asbury District 15 School was built in 1891 at what is today the northeast corner of Asbury and Woodruff Roads. This photograph, taken in 1896, shows teacher Benjamin Fiscus (second row, far left) with over 30 of his students. Records show that he was paid a salary of $52 a month for his work at the school. Fiscus later married Lottie Van Saun, one of the eighth-grade girls in the photograph (second row, seventh from right). The privy or outhouse used by the boys is clearly seen to the right of the school building. The outhouse for the girls was at the left of the school and is not seen here. A 10-foot-high fence reportedly stood at the back of the school, separating the boys from the girls.

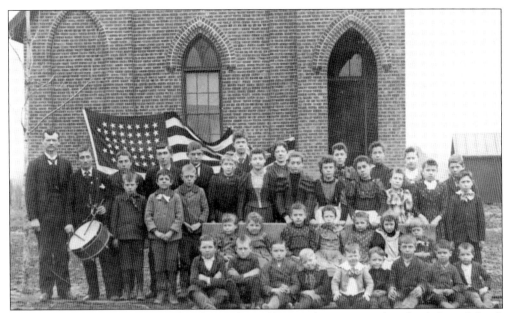

Around 1893, teacher Martin Wheatley and 37 of his pupils are pictured at the Asbury School. Wheatley received a salary of $52 a month. His teaching certificate, dated 1892, indicates that he received scores of 100 on tests of writing, arithmetic, and definitions; 95 in physiology; 90 in reading and US history; 80 in orthography; 75 in geography; and 70 in English grammar.

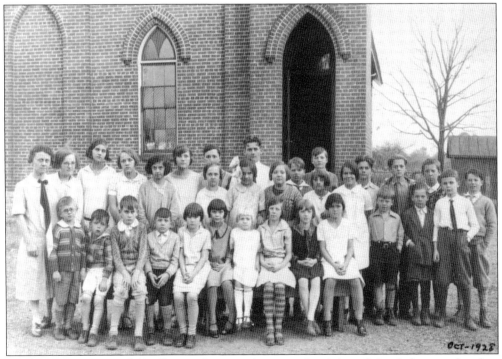

Teacher Bessie Ayer and 31 of her students are shown in this Asbury School photograph, taken in October 1928. The Asbury School closed when the central Anderson School opened in the fall of 1929. The building burned down in the late 1930s.

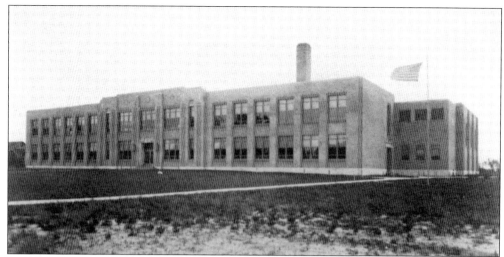

In 1927, residents of the township passed a bond issue of $165,000 to purchase land and build a central school that would offer classes through high school. The new school opened in the fall of 1929 with 525 pupils ranging from first to 11th grades.

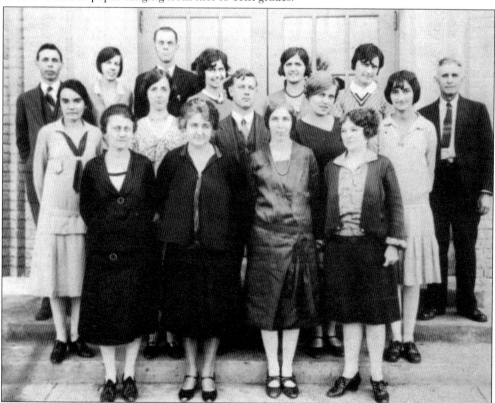

The new Anderson Township School started with a faculty of 16. Shown in this 1929 photograph are, from left to right, (first row) Bessie Ayer, Florence Bath, Nancy Laugh, and Emma Johnson; (second row) Georgia Ayer, Rosa Straus, Andrew Bylenga, Brenda Bigelow Strubbe, and Catherine Smythe; (third row) Harold Z. Maddux, Helen Hawkins Smythe, Robert E. Wright (superintendent), Mary Struke, Elsie Harmon, Willina Davis, and Bertram J. Maddux.

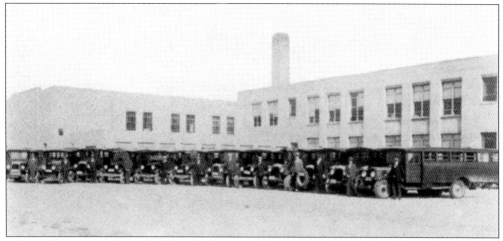

The Anderson Township School was built at the southeast corner of the intersection of Beechmont Avenue and Forest Road. A fleet of privately owned school buses picked up students throughout the township and brought them to the central school each morning and took them home at the end of the school day.

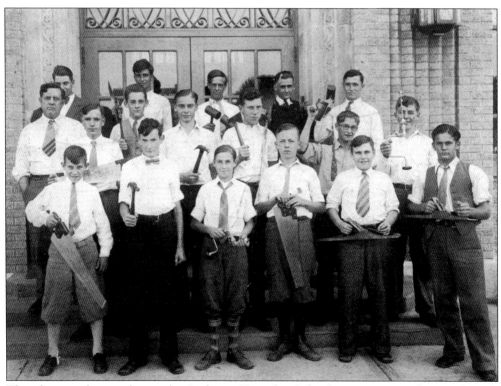

This photograph was taken at the Anderson Township School entrance around 1931. The title "Old Industrial Arts" is written on the back of the image. The boys seem to be having fun posing with tools from their class. Faculty member M. Jay Ellis (second row, far left) taught manual arts, science, and ancient history.

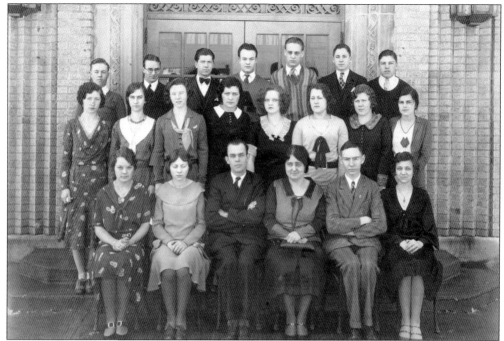

The first senior class of Anderson Township School graduated at a commencement held on May 23, 1931. Robert E. Wright, superintendent, and Florence Bath, principal and senior advisor (seated in the first row, center), are pictured with the senior students above. The school orchestra was featured in *The Andersonian* of 1931, the first yearbook. As the population of the township grew in the 20th century, so did the public schools, with enrollment reaching 8,950 during the 1974–1975 school year. Today, Anderson's Forest Hills School District includes six neighborhood elementary schools throughout the township, the Nagel Middle School, and two high schools, Anderson and Turpin.

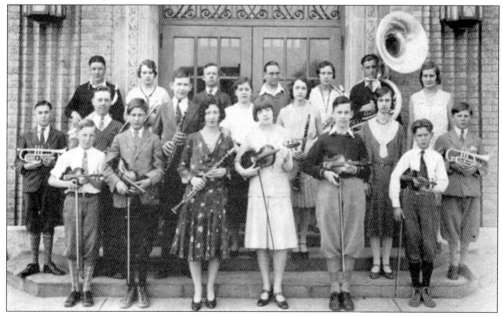

Six

WORLD WAR I

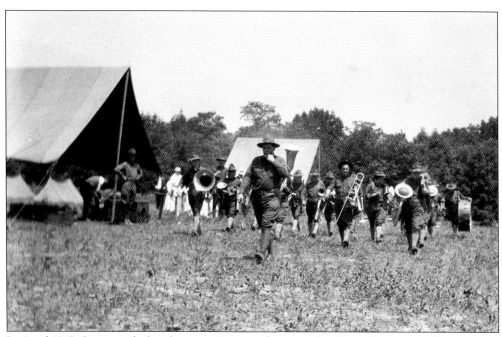

In April 1917, Congress declared war on Germany, bringing the United States into the European war. Some Ohio soldiers started their training in Anderson at Camp Procter, called "the most beautiful private regimental parade grounds in America" by *Scarborough's Official Tour Book* (1917). William Procter, commanding officer of the local Ohio National Guard and president of Procter & Gamble Company, had set up training grounds for the Guard in Anderson in 1915.

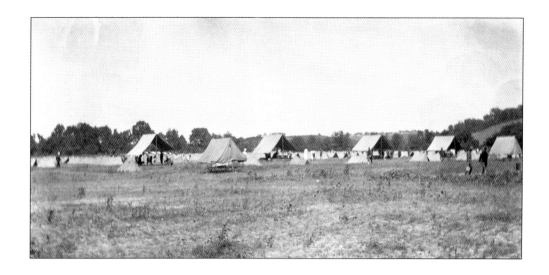

Camp Procter was reached by a steep road up from Kellogg Avenue, west of Four Mile Road. In the first years of the camp, men of the National Guard spent their weekends at target practice and drilling. By May 1917, there were about 350 men in intensive training at Camp Procter. Reports describe how the men found every minute between reveille and taps occupied. Many became Company K of the 1st Ohio Infantry, while some remained part of a specialized machine gun company. Most became federalized and went to France as part of the American Expeditionary Forces. These photographs were taken in 1917 by Ed Collord (1897–1971) of Mount Washington, who trained at Camp Procter. He served in the Army in France until his honorable discharge in April 1919.

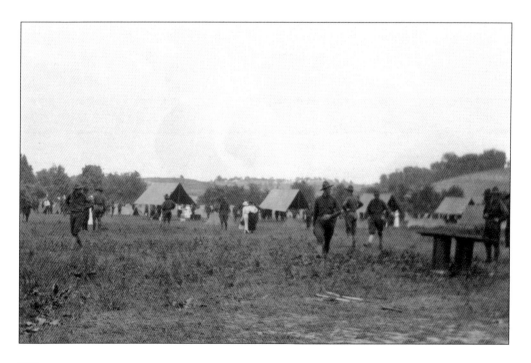

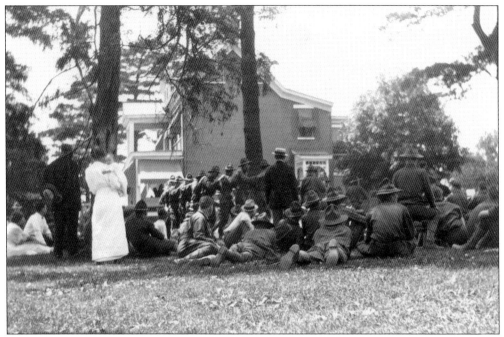

Throughout 1917, reports of training at Camp Procter appeared in Cincinnati papers. On Sundays, visitors came to the camp. Bayonet drills, exhibitions of military maneuvers, and practical demonstrations of the use of rifles were shown to spectators. The *Enquirer* of August 20, 1917, reports "nearly thousand visitors flocked to Camp Procter yesterday. A dress parade was held by the Machine Gun Company and men of K Company."

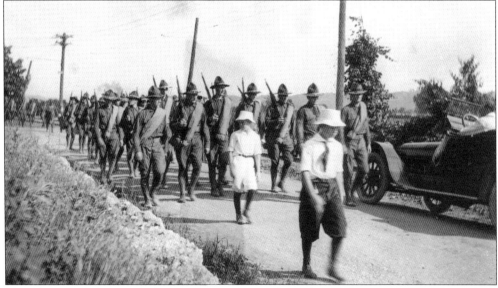

This photograph shows men from Camp Procter marching along Kellogg Avenue to Coney Island to board a boat to downtown Cincinnati. They then traveled to Blanchester, where they were federalized into the regular Army. In the 1920s, the Miami Valley Council of Girl Scouts owned the camp. Later, the area was used for agriculture until the mid-1950s, when it was developed as the subdivision Riverview Heights.

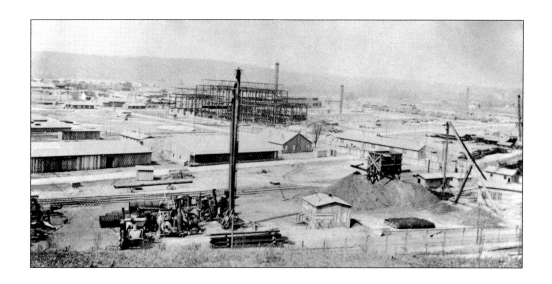

The ANCOR section of northeastern Anderson is named for the World War I project in the area in 1918. The Air Nitrates Corporation (ANCOR) was a huge project to build a facility to extract nitrogen from the air to make nitrates that could be used to manufacture explosives needed for the war effort. In April 1918, the US government announced it would build a $15 million plant on a 1,300-acre site on Broadwell Road. Construction started in August 1918. For three months, more than 6,000 men worked to lay out the site for industrial buildings, warehouses, homes for the proposed workers, highways, railroad sidings, and water and sewage systems. These photographs show the site development. The project collapsed in November 1918, when the armistice ending fighting was signed. The unfinished plant was abandoned after $5 million had been spent.

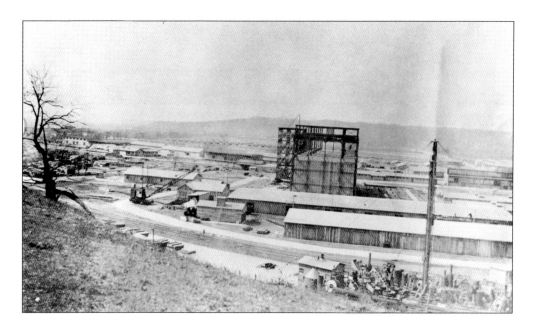

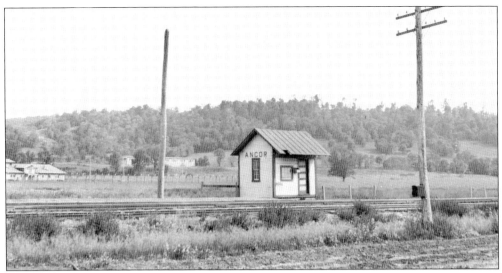

For a time, there was a special post office for the ANCOR site. This photograph from 1922 shows the ANCOR railroad station and some of the abandoned buildings. The name remained even as the area turned back to farmland and the government liquidated its holdings. For a brief period in the late 1920s, an airplane building plant operated in one of the reconditioned ANCOR buildings.

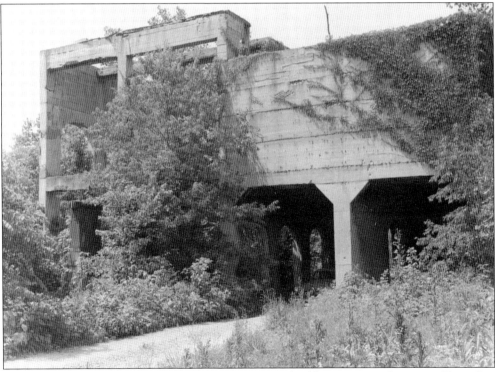

This 1930 photograph shows an abandoned ANCOR building. A 1940 *Cincinnati Times-Star* article describes how a few ANCOR warehouses are still standing, surrounded by cornfields dotted with abandoned white concrete pillars. The author points out that the ANCOR site "above high water, with good roads, railroad service, water supply and other utility services, remains an ideal spot for a great war industry."

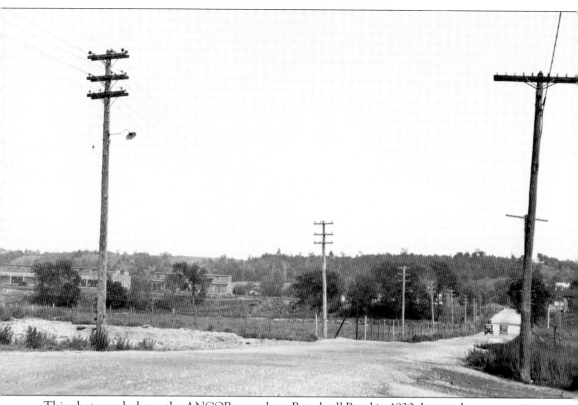

This photograph shows the ANCOR area along Broadwell Road in 1930. It records a moment in the area's long history. In the following decades, there was extensive mining of the region's deposits of sand and gravel. By 1970, industries at the ANCOR site included the Heekin Can Company, Senco Products, Dravo Corporation, US Concrete Pipe Company, and a subsidiary of the National Lead Company. This region had once been known for ancient earthworks. The Turner Earthworks included a large, oval enclosure and a set of parallel walls connecting to an enclosure on a terrace of the Little Miami River. In 1882, excavations were carried out by Dr. Charles Metz and Frederic Ward Putnam of Harvard University's Peabody Museum. They uncovered an amazing variety of artifacts. Work in recent years has established that Hopewell peoples occupied the site between AD 53 and 537. Although the earthworks can no longer be found, reminders of early farms are still present. East of Mount Carmel Road is a cluster of historical structures, including the c. 1835 Broadwell Home, listed in the National Register of Historic Places.

Seven

STORMS AND FLOODS

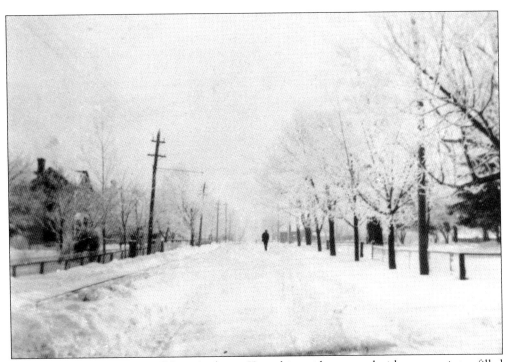

Photographs from years past tell how Anderson Township residents coped with stormy winters filled with ice and snow. The winter of 1917–1918 was one for the record books, with over three feet of snow lasting into March. This 1918 picture shows one fellow walking on a deserted Beechmont Avenue along the stretch between Wolfangel Road and Asbury Road.

Asbury Road appears completely covered with mounds of snow during the winter of 1917–1918, when over three feet of snow was recorded. It is not obvious that any traffic was moving on the street. The taller piles indicate earlier efforts to shovel snow from walkways and driveways.

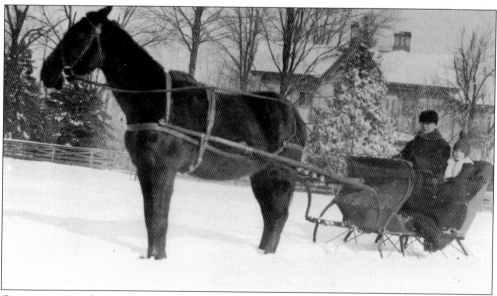

One way to travel on snow-covered streets was by horse-drawn sleigh. Here is the sleigh of the Langdon family of Mount Washington traveling along Beechmont Avenue around 1910. Dr. William Carson Langdon used his sleigh to reach his patients throughout the township during the winter months, when snow blanketed the ground.

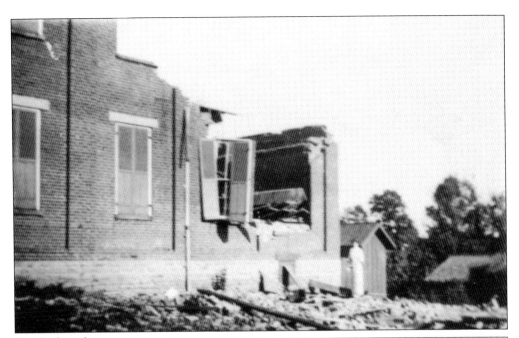

On the list of severe weather events in Ohio history is the "Great Storm" that struck Cincinnati and its vicinity, including the Anderson area, on the evening of July 7, 1915. Headlines spoke of tornadoes, but no funnel clouds were seen. At the corner of Beechmont Avenue and Eight Mile Road, the Cherry Grove Evangelical United Brethren Church building was heavily damaged (right). The congregation was able to repair the church. Across the street, the Cherry Grove District 4 School, however, was demolished and had to be replaced (above). Throughout the area, stands of timber, fruit and shade trees, shrubbery, farm crops, and gardens were damaged. Farmers were hard-hit; corn was flattened and tomatoes looked blighted.

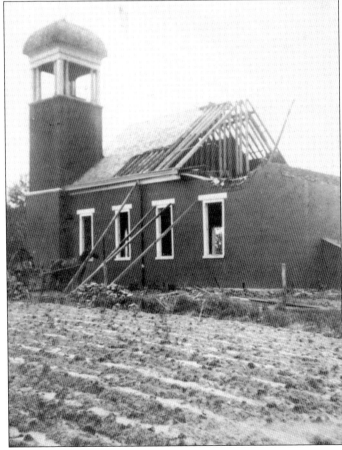

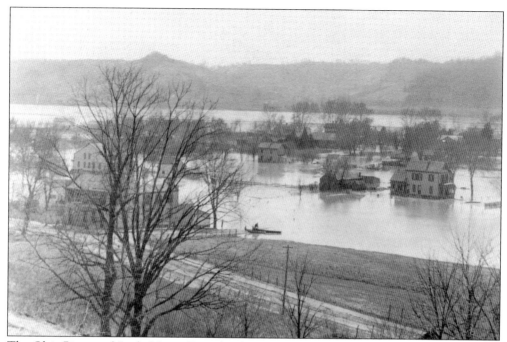

The Ohio River and Little Miami River border Anderson on the south, west, and north. The rivers were important transportation routes for travel and business, but before modern dams and flood control measures, floods were all too common. In 1901, the spring floodwaters of the Ohio River surrounded most buildings of the village of California.

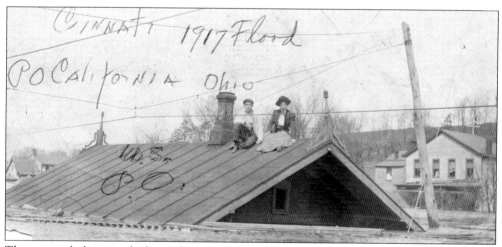

This unusual photograph shows the plight of the post office staff of the village of California during an Ohio River flood in 1917. Mail carrier Arthur Ryall and postmistress Lottie B. Steinmetz retreated to the roof of the post office as the floodwaters surrounded the building.

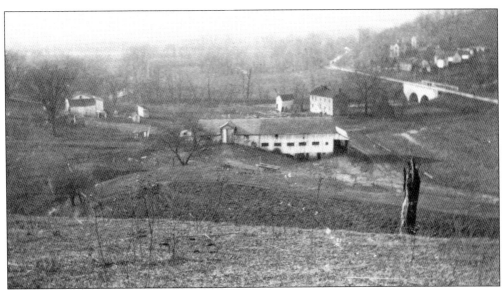

The dairy farm of the Ferris family was located at the foot of Beechmont Hill in the fertile lower Little Miami River valley. Beechmont Avenue and the bridge built over Clough Creek in 1907 can be seen at the left side of this image, taken about 1910. The Little Miami River is seen off in the distance.

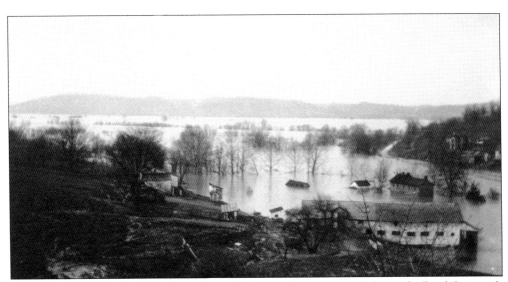

In 1913, an enormous flood along the Little Miami River covered the wide floodplain with several feet of water. The buildings of the Ferris farm were surrounded. On April 9, 1913, the high floodwaters caused the nearby 353-foot suspension bridge over the Little Miami to collapse. This bridge, built in 1876, was a critical link between Cincinnati and Anderson Township and other communities to the east of Cincinnati.

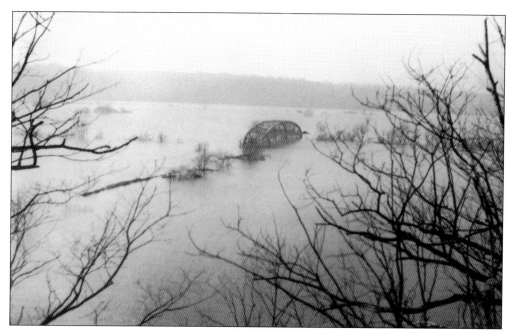

The Ohio River flood during late January and February 1937 was unprecedented. Anderson Township was cut off from the rest of Hamilton County as the waters rose and closed all the connecting bridges over the Little Miami. Newspapers offered maps showing a 69-mile detour to get from downtown Cincinnati to Mount Washington via Milford, Williamsburg, and Bethel. Books are filled with stories and images of the 1937 flood. Here are a few photographs taken by local residents. Above is a view of the bridge over the Little Miami River at Kellogg Avenue. The Little Miami valley was a sea of water. The photograph below was taken looking down a main street in the village of Newtown on January 27. Diary entries included comments such as "Houses were upset and covered with water. Newtown was almost washed away. Pitiful sights everywhere."

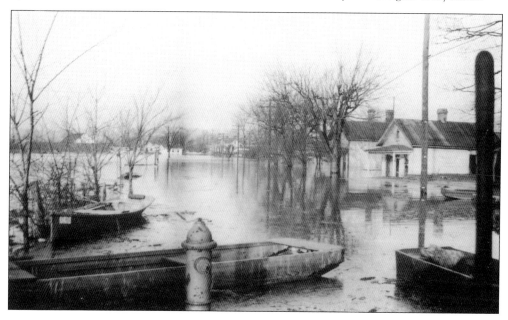

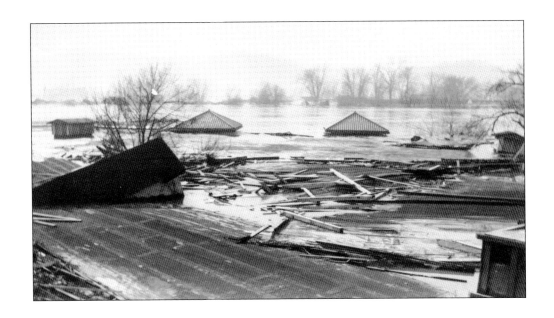

These photographs were taken at the entrance to Coney Island amusement park on Kellogg Avenue. The photograph above shows the park completely submerged by the 1937 floodwaters of the Ohio River. Only the tops of the entrance gate are seen above water. The Ohio River crested at 79.9 feet, nine feet higher than any known record. The floodwaters devastated the park. The photograph below illustrates the tremendous amount of flood debris that needed to be cleaned up after the floodwaters receded. Reports indicate that some 200 workers labored for more than four weeks to clean up the grounds of the park using steam shovels, bulldozers, and trucks.

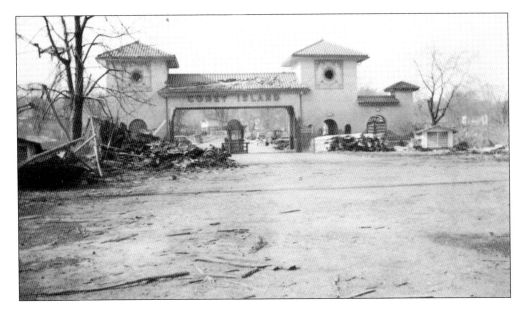

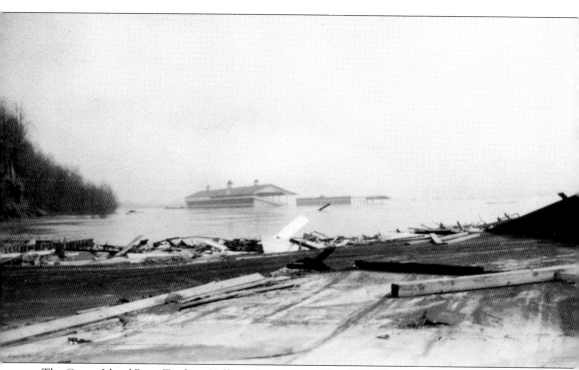

The Coney Island Race Track on Kellogg Avenue opened in 1925. The initial seasons were a great success. The *New York Times* reported that at the Cincinnati Derby held at the track on July 24, 1926, some 35,000 racing enthusiasts cheered the winner Crusader as he trotted to the judges' stand. Cincinnati hotels were filled and Cincinnati society was out in force for the derby. The 1937 floodwaters of the Ohio River completely covered the track, surrounded the grandstand, and damaged the facilities. The stables of the racetrack washed downriver and damaged the bathhouse at Coney Island. This photograph was taken after the highest floodwaters had receded. The grandstand at the track can be seen in the distance still surrounded by river water. The image shows some of the mounds of debris that needed to be cleaned up and removed before repairs could be undertaken. In 1937, after the flood, the refurbished racetrack was renamed River Downs. Today, it is the site of the Belterra Park Gaming and Entertainment Center.

Eight

PLAYTIME AND PLEASURES

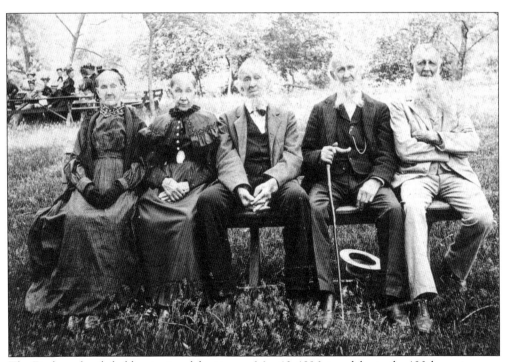

The Durham family held a picnic celebration on May 13, 1896, to celebrate the 100th anniversary of the arrival of the Joshua Durham family at the lower Little Miami valley. The *Cincinnati Enquirer* reported that a large crowd of Durham descendants enjoyed themselves with feasting and merrymaking. Pictured here are five children of Aquilla and Harriet Durham, all born in a log cabin along what is now Little Dry Run Road.

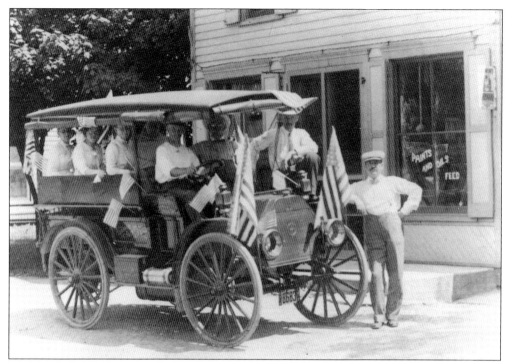

In the early decades of 1900s, the Sheldon Hardware store was on the south side of Beechmont Avenue in Forestville, now the Festival Market area. It sold a variety of wares, from farming supplies and building materials to home goods. Douglas Sheldon (1850–1931) was one of the first merchants in the area to offer deliveries. In the 1913 photograph above, his International Harvester delivery truck is decorated for the Fourth of July. The passengers seem ready to celebrate the holiday. In the c. 1916 photograph below, the vehicle is used to take a Sunday school class out for a ride and a picnic. Sheldon (second from right, the gentleman with the mustache at the front of the vehicle) made good use of his large delivery truck to transport the group through the fields.

In the early 1900s, playing baseball in local leagues was a popular sport for the men of the township. The members of the 1909 Forestville/Cherry Grove baseball team are, from left to right, (first row) Theodore T. Hawkins, Frank Ludlow, Julius Richardson, Ed Hawkins, and Frank Kuhn; (second row) Wilbur Hawkins, George Richardson, Roy Johnson, and Garrett Van Saun; (third row) Ed Johnson, Sanford Johnson, Charlie Lucas, George Hirschman, and James Johnson.

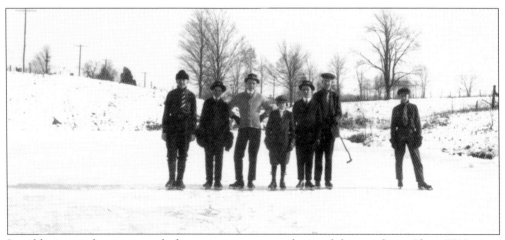

In cold winters, the many ponds that were once scattered around the area froze. About 1910, some local boys enjoyed skating on the frozen pond south of Beechmont Avenue and west of Birney Lane near the Guardian Angels Church. From left to right are Werner Eich, Edwin White, Henry Nielsen, two unidentified, Harlan Langdon, and Herbert Frazer.

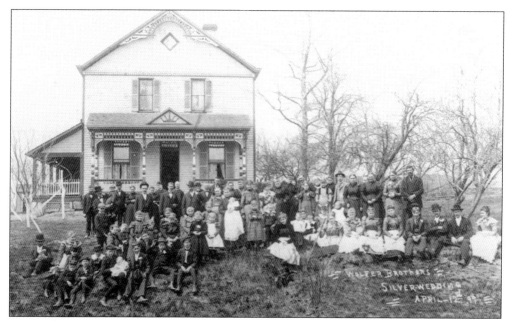

Two Wolfer brothers celebrate their silver wedding anniversaries on April 12, 1899, with a large family gathering at the Wolfer farm, located on today's Hunley Road. Anthony Wolfer married Philomena "Minnie" Leuser and his younger brother Frank Joseph Wolfer married Clara Anna Lipps at St. Stephen Church in Cincinnati in April 1874.

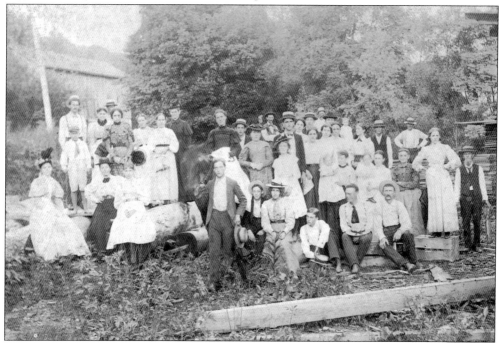

This summer gathering of the extended family of Charles M. Hopper and his wife, Nancy Anna Bennett Hopper, marks the ninth birthday of their son W. Forrest Hopper. The photograph has the precise date of July 24, 1890, recorded on it. Family and friends gather on the Hopper farm along Markley Road and take advantage of piles of wood and construction boards for seats.

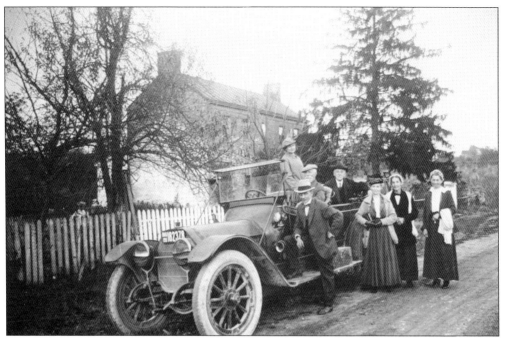

United Brethren bishop George Mathews (1848–1921) grew up in Anderson Township. In October 1916, he decided to tour his boyhood home with his family. The traveling party poses for a photograph at 7024 Salem Road. Bishop Mathews is in the center of the group, seated in the rear seat of the car. The unpaved road looks better suited to the usual wagons and carriages than the new automobiles.

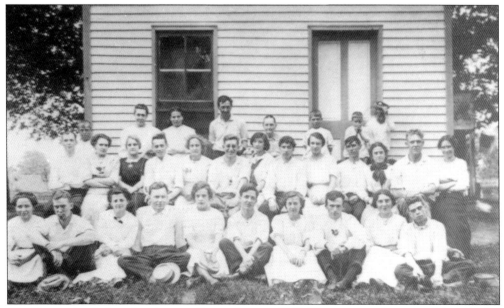

The Burnes family bought a farm on Birney Lane in 1907. Their many relatives and friends who lived in Cincinnati enjoyed coming out to the countryside on weekends for picnics and parties. The interurban railroads active in the township in the early decades of the 1900s made the excursions possible for the city dwellers.

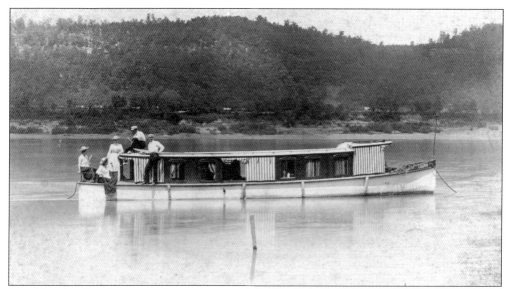

Local families found ways to relax and stay cool during the hot summer days. These photographs from about 1900 illustrate some summer activities of the family and friends of Stanley Ebersole (1860–1944). He enjoyed boating on the Ohio River on his friend Bert Finch's launch *Laura*. Stanley and relatives gather in the shade of the tall trees that grew around the Ebersole home, built by his grandfather on a hill above the river in 1808. The ladies are wearing summery, light-colored, loose-fitting dresses, and the men are in the casual wear of the times. The enormous hats of the ladies played a practical role in providing needed protection from the sun.

In February 1922, Thelma Widman's parents gave her a journal, *A Girl's Graduation Days—A Chronicle*, in which she could record the events of her senior year at Withrow High School. Thelma wrote in the journal faithfully throughout the year and pasted in photographs and souvenirs. She wrote of a special picnic on Labor Day 1922. She and her friends got up at 5:00 a.m., left their homes near Mount Washington, and walked along Beechmont Avenue, down Paddison Road, and over to Clough Creek. They sang almost all of the way and watched the sun rise. They cooked breakfast on the creek. Mildred made the cocoa, Christina fried the eggs, and Gertrude fried the bacon. After breakfast, the girls went in wading. Thelma recorded in her journal that two of girls "wore their socks rolled on our way home. A glorious day."

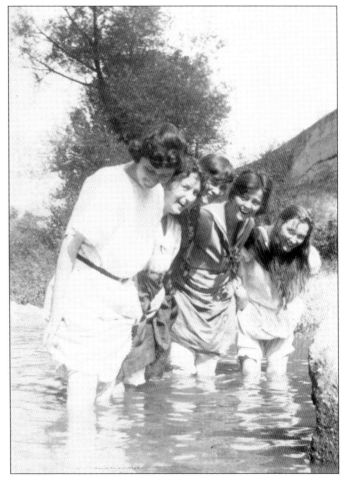

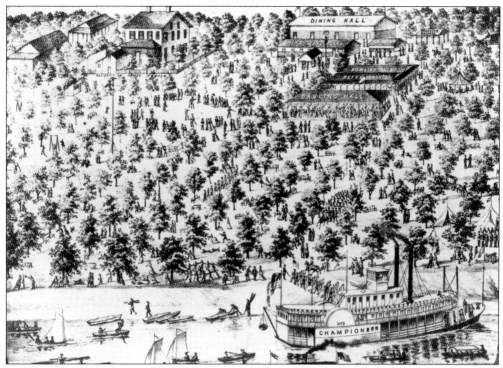

Since the late 1800s, Coney Island has been a special place for play, pleasure, and entertainment along the Ohio River. Coney Island had its start in the 1870s as Parker's Grove, a delightful picnic area in the apple orchard of James Parker. On June 21, 1886, it opened with great fanfare as "The New Coney Island of the West."

A postcard from about 1908 celebrates the "majestic shade trees" at Coney Island. Riverboats were the popular way to reach Coney from the city. Thousands came to enjoy the cool breezes and many amusements of the developing park. In 1893, Lake Como was created on the expanded grounds, offering more entertainment and interesting rides.

Potato Races

Free to all girls over ten years of age.
 1st Premium $2.00 2nd Premium . . . $1.00

Free to all girls under ten years of age.
 1st Premium $2.00 2nd Premium . $1.00

Base-Ball

One game by opposing nines to be made up of boys over twelve years of age, winning team $3.00

One game by opposing nines to be made up of boys under twelve years of age, winning team $2.00
National Association Rules.

Athletic Contests to be made up of any Anderson Township Scholars of ages stated, but not to be made up from any particular school.

We feel that our efforts in promoting and stimulating the Higher Education in Anderson Township Schools has been mainly successful through the hearty cooperation we have had from parents and teachers for which we most sincerely thank you all, and ask that you again join us in making June 5th, 1909 another successful and enjoyable School Field Day.

 Yours sincerely,
 THE CONEY ISLAND COMPANY.

Base-Ball
Running Races
Sack Races
Potato Races
Red Lemonade
A Bully Good Time

Hennegan & Co. 8th, near Main

FOURTH ANNUAL OUTIN

— OF —

ANDERSON TOWNSHI
.. PUBLIC SCHOOLS .

AT

CONEY ISLAND

Saturday, JUNE 5, 1909

Starting in the late 1880s, Harvest Home celebrations were held at Coney Island for local communities. Anderson Township held its 10th Annual Harvest Home event at the park in 1896 with country fair exhibits of livestock and displays of fruits and vegetables and household items. This leaflet illustrates another tradition held at Coney for the residents of Anderson Township. The fourth annual outing of the Anderson Township Public Schools was held on Saturday, June 5, 1909. The School Field Day featured athletic contests and promised "A Bully Good Time." Cash prizes were offered to the winners of the races and the winning baseball teams.

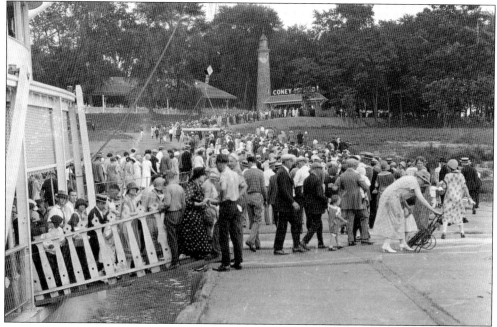

In 1924, new owners led by Rudolph Hynicka and George Schott began the rebuilding and expansion of Coney Island. They set up new rides and attractions, built Coney's famous Sunlite Pool, and opened a dance hall known as Moonlite Gardens. In 1925, the new *Island Queen* excursion steamboat began its popular trips from Cincinnati out to the welcoming river gate entrance of the park.

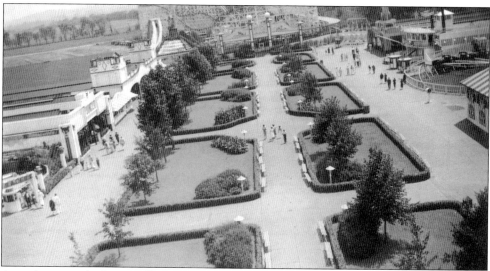

Attendance reached one million in 1936, when Coney celebrated its Golden Jubilee Year. This photograph shows the Mall, the heart of the park, early in the day on August 29, 1936. After a major flood in 1964, plans began to relocate Coney Island. Kings Island was opened in Mason, Ohio, in 1972. Coney closed in 1971 but reopened as Old Coney in 1973. It still attracts crowds every summer season.

Nine

Past and Present

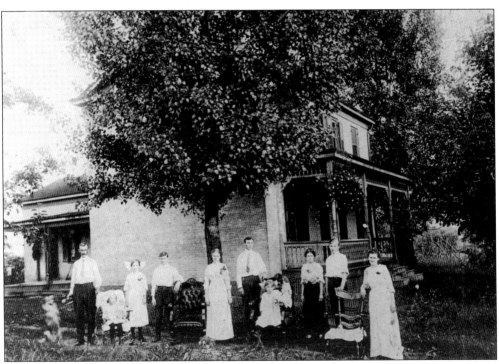

Landmarks of the past are present throughout the township today. This house, thought to be have been originally built by James Bellville in the 1820s, is today the Anderson Township Heritage Center at the southeast corner of Forest and Eight Mile Roads. Pictured are Albert and Ella Mardis and their family when they lived in the home in 1912.

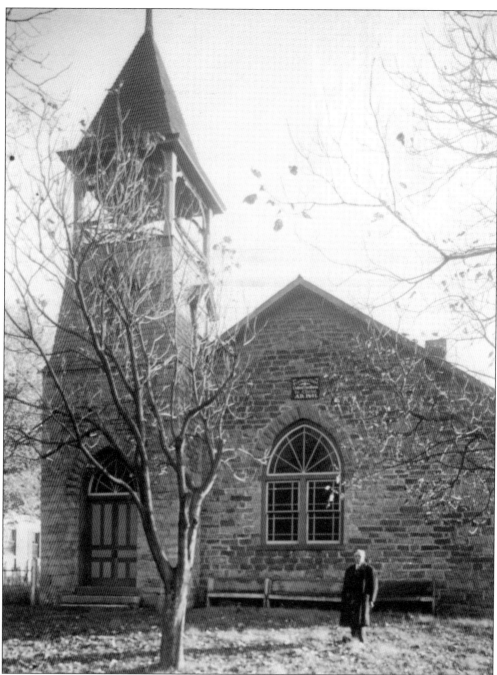

In 1916, United Brethren bishop George Martin Mathews (1848–1921) toured Anderson Township and visited the sites he remembered from his childhood, including the Old Stone Church on Five Mile Creek, which he attended as a young boy. Jacob Markley donated the land in 1844, and the church was built by local families with stones hauled from the nearby creek and hillsides. The bell tower and entrance were added in 1896. Today, the Five Mile Chapel and the surrounding cemetery at 6975 Five Mile Road are listed in the National Register of Historic Places. The site is cared for and preserved by the nonprofit Five Mile Chapel Society.

The remarkable James Clark stone house stands at the busy corner of Clough Pike and Hunley Road. The Clark family arrived in Anderson in 1797 and built the stone house about 1802. Today, the property, pictured in 1968, is owned by Anderson Township. The grounds surrounding the house are rented to a nursery farm, a pleasant reminder of the area's farming history.

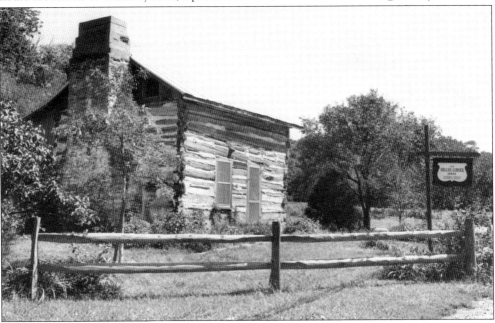

The Miller-Leuser Log House, dating to 1796, stands at the corner of Clough Pike and Bartels Road. The Anderson Township Historical Society purchased the house in 1971; this photograph dates to 1972. The log house was added to the National Register of Historic Places in 1974 and was awarded an Ohio Historical Marker in 2010. The society offers tours of the house on a regular schedule from May to October.

BIBLIOGRAPHY

Ford, Henry A. and Kate B. Ford, compilers. *History of Hamilton County Ohio with Illustrations and Biographical Sketches.* Cleveland: L.A. Williams Company, 1881.

Frame, Marjorie A. *Anderson Township: How It Began.* Cincinnati: Anderson Township Historical Society, 1970.

Giglierano, Geoffrey J. and Deborah A. Overmyer. *The Bicentennial Guide to Greater Cincinnati: A Portrait of Two Hundred Years.* Cincinnati: The Cincinnati Historical Society, 1988.

History of Cincinnati and Hamilton County, Ohio: Their Past and Present. Cincinnati: S.B. Nelson & Company, 1894.

Jacques, Charles J. Jr. *Cincinnati's Coney Island.* Jefferson, OH: Amusement Park Journal, 2002.

Lepper, Bradley T. *Ohio Archaeology: An Illustrated Chronicle of Ohio's Ancient American Indian Cultures.* Wilmington, OH: Orange Frazer Press, 2005.

McNeil, David. *Railroad with 3 Gauges: The Cincinnati, Georgetown & Portsmouth RR and Felicity & Bethel RR also with material on The Interurban Railway & Terminal Co. and The Ohio River & Columbus RR.* Cincinnati: David McNeil, 1986.

Newtown, Ohio, 200th Anniversary, Bicentennial Edition 1792–1992. Newtown: Newtown Historical Committee, 1992.

Scamyhorn, Richard and John Steinle. *Stockades in the Wilderness: The Frontier Defenses and Settlements of Southwestern Ohio 1788–1795.* Dayton, OH: Landfall Press, 1986.

Smalley, Stephen B. *A History of Mt. Washington: A Suburb of Cincinnati, Ohio.* Cincinnati: Anderson Township Historical Society, (1971) 2009. First printed 1967 by Mt. Washington Press.

———. *Now and Then in Anderson Township.* Cincinnati: Anderson Township Historical Society, (1987) 1990.

Smith, Alma Aicholtz. *The Virginia Military Surveys of Clermont and Hamilton Counties, Ohio, 1787–1849.* Cincinnati: Alma Aicholtz Smith, 1985.

ABOUT THE ANDERSON TOWNSHIP HISTORICAL SOCIETY

In 1968, the Anderson Township Historical Society was founded in response to the community's desire to study, collect, preserve, and teach local history. The purchase of the historical log house on Clough Pike, made possible by the generous support of members and friends, was an important effort in 1971. The challenging obligation to restore, maintain, and furnish this building and to utilize it to the fullest and best advantage of the community remains a vital part of the Anderson Township Historical Society's commitment. In 1974, the Miller-Leuser Log House was entered in the National Register of Historic Places. In June 2011, we celebrated the installation of an Ohio Historical Marker for the property.

In 1973, the brick house on an adjoining lot was acquired and is now used as the society's office. The genealogy and research libraries are open by appointment. In recent decades, adjoining property has been purchased; the Anderson Township Historical Society land now totals more than 10 acres dedicated to the society's preservation and educational goals.

Meetings of the society are held 10 months of the year on the first Wednesday of the month. Meetings include programs of historical interest followed by refreshments and fellowship. The historic Miller-Leuser Log House and grounds are open for tours on the first and third Sundays from May through October from 1:00 to 4:00 p.m. Special tours for schools and other groups are available by advance appointment.

The History Room at Anderson Center, 7850 Five Mile Road, a joint project of Anderson Township and the historical society, offers photographic displays, hands-on exhibits, and artifacts illustrating the history of the township. Docent volunteers from the society host open hours at the History Room on Sunday and Wednesday afternoons and on Tuesday evenings.

The Anderson Township Historical Society is a nonprofit Ohio corporation, authorized by Section 501(c)(3) of the Internal Revenue Code. Contributions are tax deductible and always acknowledged. Membership in the ATHS offers an opportunity to be a part of this vital organization.

For more information, see on the web: www.AndersonTownshipHistoricalSociety.org.

DISCOVER THOUSANDS OF LOCAL HISTORY BOOKS FEATURING MILLIONS OF VINTAGE IMAGES

Arcadia Publishing, the leading local history publisher in the United States, is committed to making history accessible and meaningful through publishing books that celebrate and preserve the heritage of America's people and places.

Find more books like this at
www.arcadiapublishing.com

Search for your hometown history, your old stomping grounds, and even your favorite sports team.

Consistent with our mission to preserve history on a local level, this book was printed in South Carolina on American-made paper and manufactured entirely in the United States. Products carrying the accredited Forest Stewardship Council (FSC) label are printed on 100 percent FSC-certified paper.

MADE IN THE